W9-BOJ-096

STUDIO VISTA

Coloured Pencil Drawing

JENNY RODWELL

STUDIO
VISTA

ACKNOWLEDGEMENTS
The author and publishers would like to thank the following artists, who have allowed us to use their work in this book: Antony Dufort, pp. 4–5; Pippa Howes, pp. 8, 10, 30–31; Adrian Smith, pp 6–7, 50–51; Camilla Sopwith, pp. 7 and 11; William Taylor, pp 8–9.
Special thanks are also due to Aco-Rexel for technical advice and for their generous help with materials; and to the following artists for step-by-step demonstrations and artwork: Humphrey Bangham, pp. 34–35, 36–41, 42–45, 60–61, 75, 76–77, 82–87; Pippa Howes, pp. 62–67, 78–81, 88–95; Adrian Smith, pp. 14–19, 44–49, 52–53, 68–73, 74–75; Jim Staines, pp. 52, 54–59; and to Fred Munden for taking the photographs.

Studio Vista
a Cassell imprint
Villiers House
41/47 Strand
London WC2N 5JE

Text copyright © Jenny Rodwell and Patricia Monahan 1994
Volume copyright © Cassell Publishers Limited 1994

All rights reserved.
No part of this publication may be reproduced or transmitted in any form or by any means, electronic or mechanical, including photocopying, recording or any information storage or retrieval system, without prior permission in writing from the publishers.

First published 1995

British Library Cataloguing-in-Publication Data
A catalogue record for this book is available from the British Library.

ISBN 0-289-80119-2

Series editors: Jenny Rodwell and Patricia Monahan
The moral rights of the author have been asserted

Distributed in the United States by
Sterling Publishing Co. Inc.
387 Park Avenue South, New York, NY 10016-8810

Typeset in Great Britain by Litho Link Ltd.
Printed in Great Britain by Bath Colour Books Ltd

CONTENTS

CHAPTER 1
PENCILS UNLIMITED 4
The late arrival 6
Their working strengths 8
A variety of uses 10

CHAPTER 2
MIXING COLOURS
WITH PENCILS 12
Colours: how they work 14
Practical mixing 16

CHAPTER 3
PENCILS AND PAPER 20
Choosing pencils 22
Making pencils 24
Choosing a surface 26
Coloured papers 28

CHAPTER 4
PROJECTS WITH PENCILS 30
Blend, burnish and erase 32
Shading 34
PROJECT: Bowl of onions 36
PROJECT: Suzie the cat 42
PROJECT: Autumn apples 44
Special effects 50
Texture and pattern 52
PROJECT: The sheep bridge 54
Watercolour pencils 60
PROJECT: Herring 62
PROJECT: Rural landscape 68
Sketching 74
Transferring a sketch 76
PROJECT: Dried flowers 78
PROJECT: Kitchen still-life 82
PROJECT: Wild flowers 88
Index 96

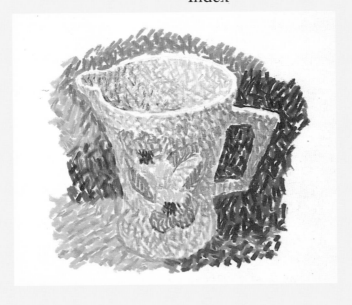

Pencils unlimited

COLOURED PENCILS are a comparatively new, still-evolving and exciting medium, in wider use now than ever before. They are far removed from the hard, bland, scratchy things that many will remember from schooldays.

In fact, forget all associations with those early childhood sets. Coloured pencils are very much a mature medium, in daily use by both professionals in studios and amateurs. They are easy to obtain, to carry and to store; they are clean and manageable – in short, ideal for beginners.

They go far beyond the tasks traditionally associated with pencil and paper. With coloured pencils, you do not merely make lines; you can establish expanses of colour and create texture with an impressive array of techniques.

Coloured pencils have often been used for the sorts of precise drawing needed by architects and scientists, among others. But they also allow you to make expressive pictures, with gestural strokes and chunky colour. By applying spots of colour, you can 'optically mix', as the Impressionists did with their oil paints. Or the transparent quality of coloured pencils can be used to build up layers of even colour.

We hope the techniques and projects in this book will encourage you to be bold and help you to enjoy putting coloured pencils to their full and varied use.

Coloured pencils are suitable for all subjects, and the work can be as sketchy or detailed as you want to make it. This figure drawing by Antony Dufort combines coloured pencils with a soft graphite drawing pencil. The initial drawing and tones were established with the drawing pencil; local colour was added with coloured pencils.

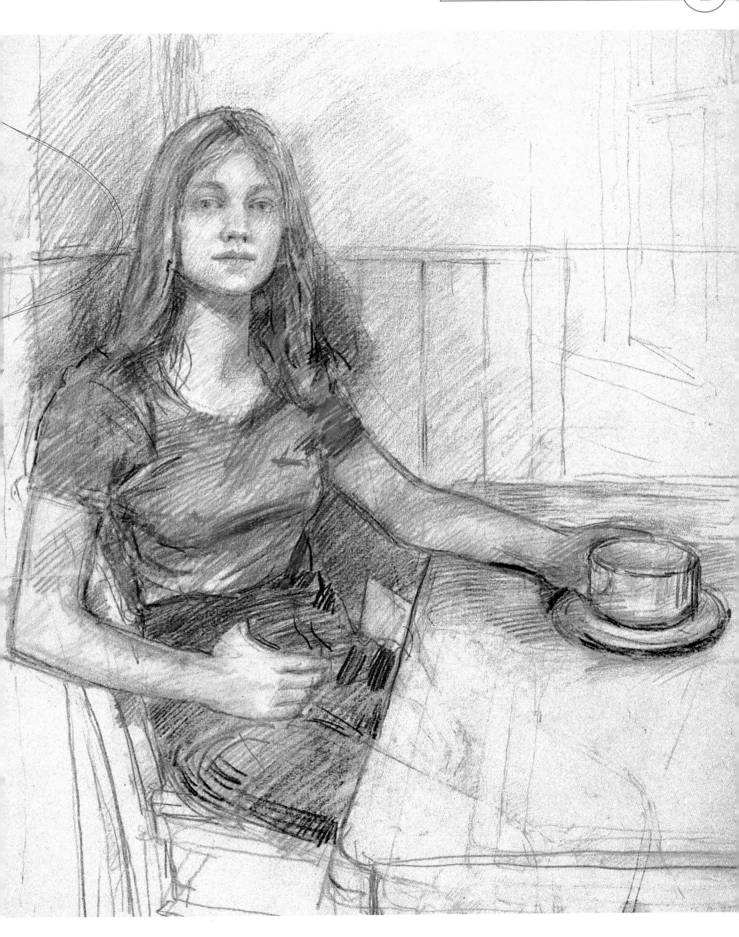

THE LATE ARRIVAL

A drawing tool often used in past centuries by great artists, including Dürer (1471–1528) and Leonardo da Vinci (1452–1519), was the silverpoint – a stylus made of silver or similar metal which produced a thin, pale-grey line. It was noticed that, instead of fading with time, the line would tarnish and become more pronounced. The silverpoint was the forerunner of the pencil.

Lead or graphite drawing pencils as we know them are a comparatively new medium. The first lead pencil was made in 1662 and pencils did not come into general use until the nineteenth century. Coloured pencils are newer still.

The earliest coloured drawing tools, made from clay and wax and earth pigments, were drawing sticks which came in natural earth colours – sepia, browns and earthy reds. Similar products, such as the familiar Conté drawing sticks, are still used. Conté continue to produce a drawing range made from traditional colours, as well as a broader, more general range.

A logical next step was to encase the drawing stick in wood, to make it easier to hold. And today nearly every manufacturer of artists' materials makes its own range of coloured pencils.

Broadening its scope

The coloured pencil was at one time thought of mainly as an illustrator's medium or as a tool for architectural plans and technical and scientific drawings. It was considered well suited to fields where colours were used symbolically rather than literally.

This has changed. Increasingly, coloured pencils have become drawing tools for all artists and for all subjects, including the rendering of flesh tones in portraits and other studies of the human figure. Pencils can produce full or limited colour. In other words, as you can see from the examples in this book, there is no longer such a thing as the typical coloured pencil drawing. Artists have developed their own techniques and approaches.

The coloured pencil is currently fashionable. It can be seen in book and magazine illustration and in animation. It is used by fine artists and art students both for making finished drawings and for preliminary studies and sketching. Trends in artists' materials change rapidly, but there will always be a place for coloured pencils.

A useful medium

Because they require no mixing, no drying-time and no fixing, coloured pencils were quickly recognized as invaluable tools for producing rapid colour sketches. Illustrators, commercial artists and designers use them for making rough drawings and preliminary sketches.

Coloured pencils are as suitable for filling in areas of solid colour as they are for drawing lines, and an artist can often produce a detailed 'rough' using nothing more complicated than a basic set of coloured pencils. The coloured rough provides the client with enough information to gain a clear impression of what the finished work will look like, even though this may eventually be done in ink, paint or another medium.

▷ **Line and colour** *Coloured pencils are a favourite medium of painter and illustrator Camilla Sopwith. In this drawing of a London meat market she worked directly from the subject, using the pencils loosely to establish an accurate line drawing with selected areas of shading and local colour.*

▽ **Sketching** *Adrian Smith is a painter who frequently uses coloured pencils for sketching and preliminary drawings. He finds them ideal for on-the-spot sketching, especially for landscape work, when light and weather conditions change constantly.*

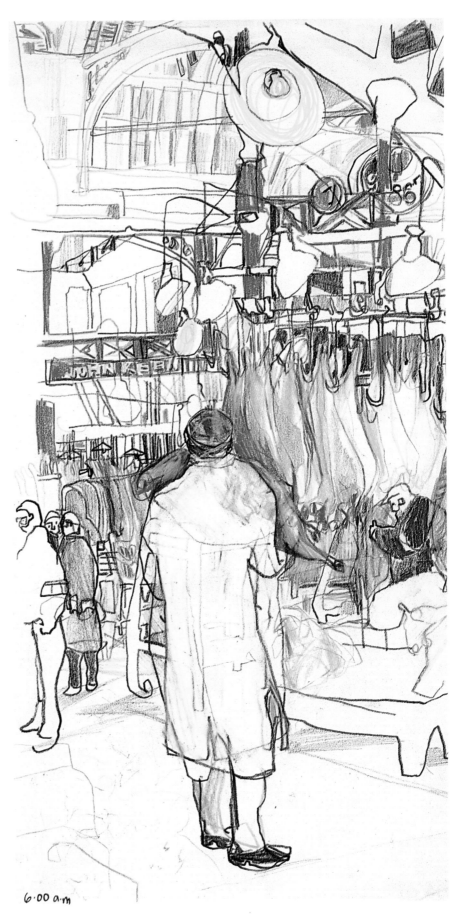

6·00 a.m

THEIR WORKING STRENGTHS

It is not only because of their portability and cleanliness that coloured pencils have become widely used by artists. For purely technical reasons, the medium is in constant demand.

Coloured pencils reproduce well, without losing any of the feel of the original. Because of this, they are used frequently in illustrations and graphic design. If you want very strong colours – stronger than you would normally achieve with the coloured pencils themselves – you can take a colour copy of the original and use this as the artwork. The copy loses some of the subtlety, but you end up with vivid, bold colours. This practice is often followed

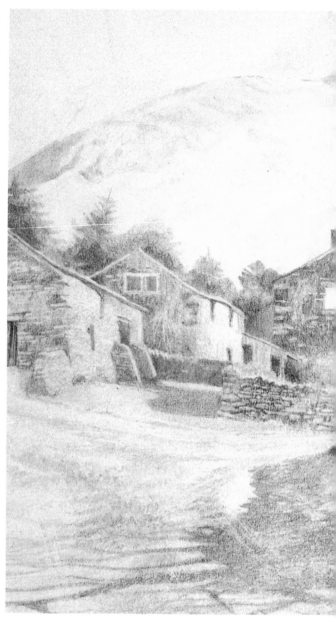

by illustrators and other artists who want their work to reproduce as brightly as possible.

The pencils are versatile. They are excellent for line drawing, yet can be used for blocking in areas of strong colour. Ideal for detail, coloured pencils can capture the intricate precision which is needed in works such as botanical illustrations. On the other hand, they can be used boldly and expressively

◁ **Illustration** *Pippa Howes is a book and magazine illustrator who works predominantly in coloured pencil and watercolour pencil. This is one of a series of sketchbook roughs, done in preparation for a book illustration.*

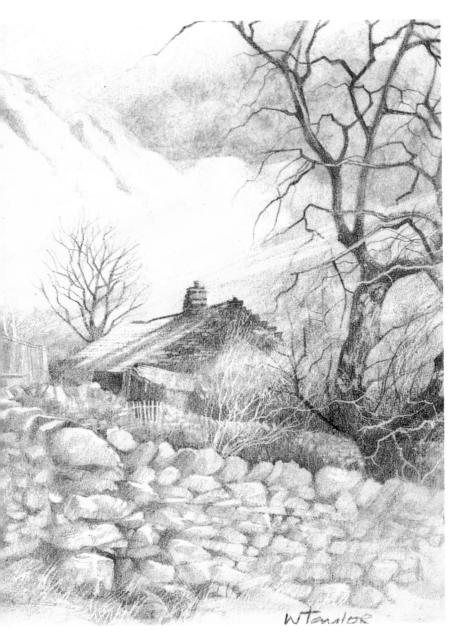

◁ **Tone and colour** *A rural landscape by William Taylor shows just how detailed and precise a coloured pencil drawing can be. Tones and colours are built up gradually and accurately with graphite drawing pencil and coloured pencils.*

on a comparatively large scale.

Coloured pencils are also good for mixed-media work, especially with watercolour and gouache, as in some of the demonstration paintings in this book.

How permanent?

The pigments used in all artists' materials are the same. And as with all of them, the colours of coloured pencils are only as permanent as the pigments. This means very permanent indeed in the case of colour-fast pigments, but not so permanent with colours which are inherently fugitive and tend to fade.

Coloured pencils are less vulnerable than soft pastels and charcoal. They do not generally smudge and usually you do not have to 'fix' the picture to preserve it.

There are, however, two occasions when you might wish to use fixative. Very soft pencils, such as pastel pencils, are crumbly and can smudge slightly. They might need the added protection of fixing. And coloured pencil drawings can also occasionally produce a wax 'bloom' – a cloudy surface which appears on the colour a day or two after it has been applied. This is not terminal; it can be removed by carefully wiping the drawing. Alternatively, a light coat of fixative when the drawing is finished will prevent the bloom developing at all.

9

A VARIETY OF USES

In the miniature here, specially commissioned for this book, the artist has exploited one of the central advantages of coloured pencils – their use as a precision tool.

But here lies danger . . . The potential fineness of the pencils themselves means they are capable of great detail and neatness. This may be a boon to certain artists, but for the newcomer to the medium a 'tight', detailed way of working could be a trap. A familiar characteristic of many beginners is that they tend to restrict themselves to clusters of detail in the centre or corner of the paper, without exploring other options.

You will see from the projects in this book just how many approaches there are to coloured pencil drawing. The artists here are all specialists in the medium and have developed their own techniques.

Beginners, however, should not specialize too

△ **An outdoor medium** *Coloured pencils lend themselves perfectly to working out of doors. They are portable, compact and clean – and you do not need water or other cumbersome additives.*

▽ **Scientific precision** *A well-sharpened coloured pencil is one of the most accurate of all drawing tools. This carefully rendered drawing of a teasel is as sharp and detailed as is the subject.*

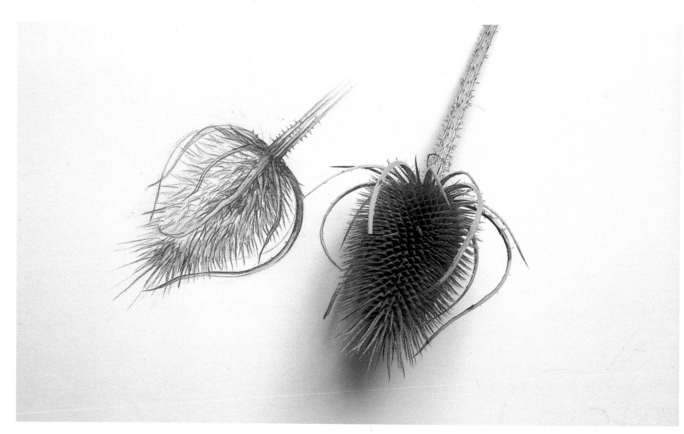

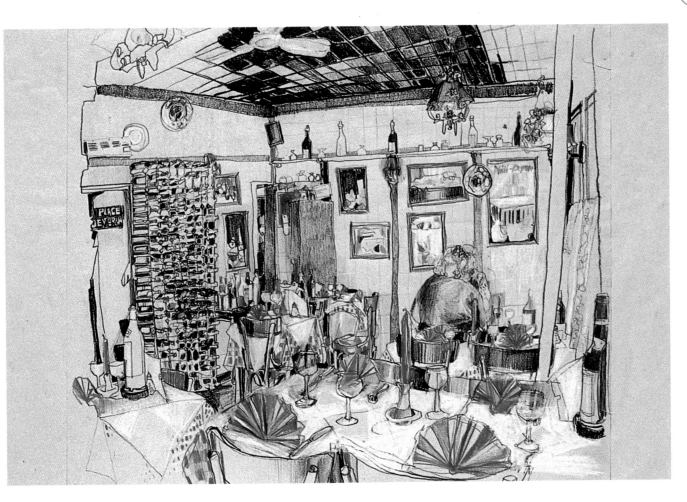

early. It is important for you to try as many as possible of the techniques demonstrated here, and go on to become familiar with the different ways in which coloured pencils can be used.

You may well end up working in your own personal style – perhaps something similar to the detailed approach illustrated here – but you will have reached that position as the result of experiment, rather than being locked in a particular way of drawing by fear or a lack of curiosity.

Diversity of scale

Experiment not only with fine pencils but with chunky colour sticks, combining the two or even using colour sticks on their own for a while. You could also find time to combine pencils with another medium – loose watercolour washes or bold gouache – to keep the work fluid and alive.

The scale on which you choose to work is important. Obviously, convenience and portability play a role, and most drawings fall within certain conventional dimensions. But you are not held to

△ **Limited colours** *A suggestion of colour can often be just as effective as a whole spectrum. This cheerful restaurant interior, drawn on the spot, was done with just three colours, plus black and white.*

these. You can make your drawing as tiny or as enormous as you like. Working on different scales is an excellent way of finding your particular talents.

For those who like working on a very large scale, some cartridge and watercolour papers are available in rolls 114cm wide. Paper bought by the roll is less expensive than pads and separate sheets, making the initial outlay worthwhile. Cut to suit your requirements.

Working with a finely sharpened pencil, you can produce a miniature like the one shown here, where every detail is visible. Yet the same materials also enable you to work on a very large scale, drawing from the elbow instead of from the wrist to give you long, broad sweeps of colour.

Mixing colours with pencils

THE OIL painter mixes colours on a palette before applying them to the canvas. Although this cannot be done with a dry medium like coloured pencil, pencil colours can in fact be successfully mixed on the paper. This is because they are transparent, resembling watercolours in this respect. Each layer becomes a translucent veil which allows the underlying colour to glow through.

There are exceptions: softer brands are more opaque. But most pencils will allow you to mix and overlay colour in various ways, as demonstrated on the following pages.

You can also achieve lights and darks with coloured pencils, either by controlling the amount of pressure as you draw or by overlaying with darker colours. Because you can control the tones, coloured pencils are not available in such large tonal ranges as pastels; a wide range of tones can be achieved using just one pencil.

Coloured pencils offer exciting possibilities. Experiment freely, trying out combinations as you develop your own colour repertoire. Mixing will soon become automatic, allowing you quickly to obtain the exact colour you want.

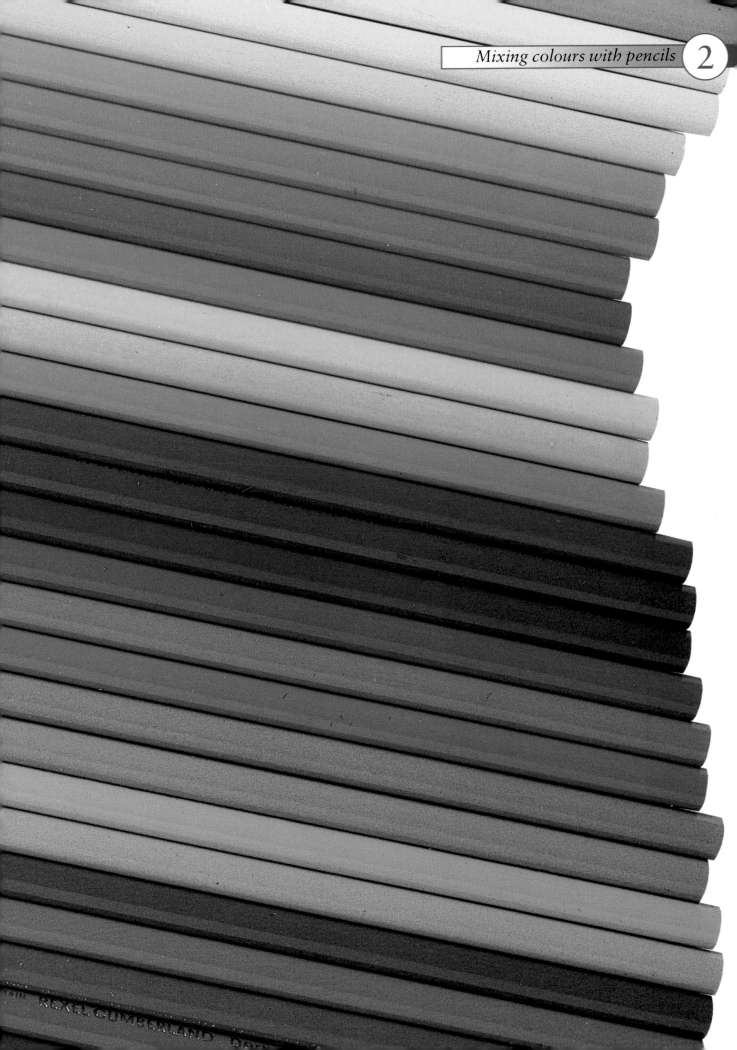

COLOURS: HOW THEY WORK

All artists, including those who work with coloured pencils, need to understand the basic theory of colours and how they interact.

There are three primary colours: red, yellow and blue. If you mix a primary with another primary, you will arrive at one of the three secondary colours: orange, which is made by mixing red and yellow; violet, made from red and blue; and green, made from yellow and blue.

There is a third category: tertiary colours. These are made by mixing one primary with one secondary. Thus we get yellowy orange, bluish green and so on.

The primaries and secondaries are easily demon-strated when we look at the colour wheel, a basic device used in art schools.

Colour opposites

The wheel is not laid out at random. The primary colours are spaced apart and between each two primaries you will find their 'offspring' – the secondary colour that results when they are mixed together.

Each colour in the wheel, whether primary or secondary, faces its opposite or complementary colour. Yellow faces violet, blue lies directly opposite orange and red faces green. This is not just a graphic theory; each colour reacts visually with its opposite. Stare at a daub of red on a piece of white paper, then close your eyes. You will notice that the opposite colour, green, has 'appeared' before your mind's eye. Look at most paintings and you will find the vibrancy often lies in a dialogue between two opposite colours.

▽ **Colour wheel** *The basic colour wheel contains the primaries and secondaries. The primary colours are red, yellow and blue. Between these lie the secondary colours – green, violet and orange. Each secondary colour is mixed from the two adjoining primaries.*

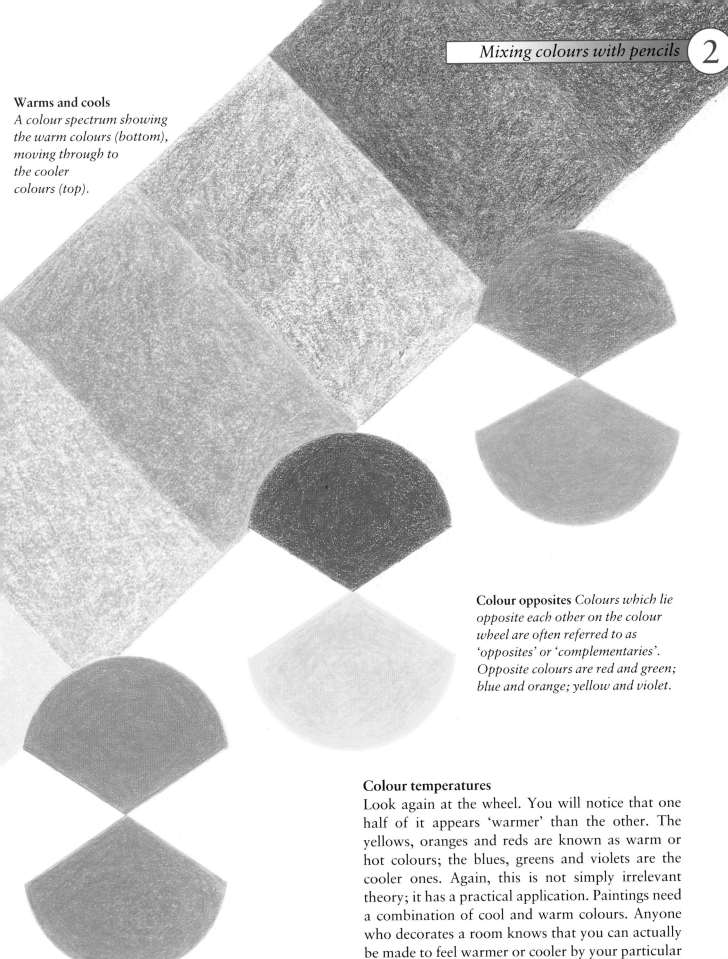

Warms and cools
*A colour spectrum showing
the warm colours (bottom),
moving through to
the cooler
colours (top).*

Colour opposites *Colours which lie
opposite each other on the colour
wheel are often referred to as
'opposites' or 'complementaries'.
Opposite colours are red and green;
blue and orange; yellow and violet.*

Colour temperatures
Look again at the wheel. You will notice that one
half of it appears 'warmer' than the other. The
yellows, oranges and reds are known as warm or
hot colours; the blues, greens and violets are the
cooler ones. Again, this is not simply irrelevant
theory; it has a practical application. Paintings need
a combination of cool and warm colours. Anyone
who decorates a room knows that you can actually
be made to feel warmer or cooler by your particular
colour scheme.

15

PRACTICAL MIXING

When putting the theory of colour-mixing into practice, coloured pencils lend themselves happily to two basic techniques: 'overlapping', where colours are mixed physically on the paper; and 'optical mixing', where colours mix in the eye of the viewer.

On the paper
In overlaying, two or more colours are applied over each other. It can be done by *cross-hatching*, when the colour is laid in fairly controlled crisscross lines, laid tightly or in a freer way. Or you can simply *scribble*, for a much looser effect.

Glazing is when thin layers of colours are laid over each other. This is usually done with the side of the sharpened pencil point, spreading a veil-like layer over the original colour. It works best with harder, more transparent, pencils. With soft pencils, the colour tends to be less flat and more textured.

The top colour is the dominant one. Blue on top of yellow produces a bluer green than doing it the other way round. This means that you can experiment and develop more subtle ways of mixing colours.

In the eye
In optical mixing, the colours are separate from each other on the paper but they produce an optical illusion – you 'see' another colour. In colour printing, for instance, separate colours are printed as tiny dots so small that you do not recognize them as individual dots but 'see' the intended colour.

The artists known as the Pointillistes did something similar. Seurat (1859–91) and Signac (1863–1935) painted dabs of pure colour – yellow and blue, for instance, instead of green; from a distance, they look green.

Colour mixing techniques

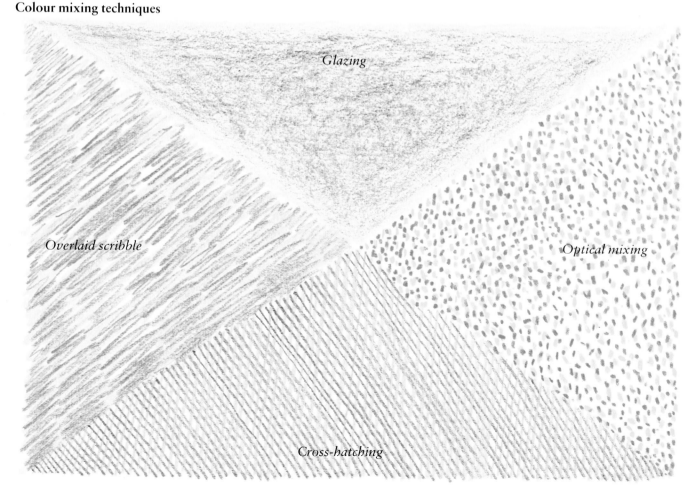

Glazing

Overlaid scribble

Optical mixing

Cross-hatching

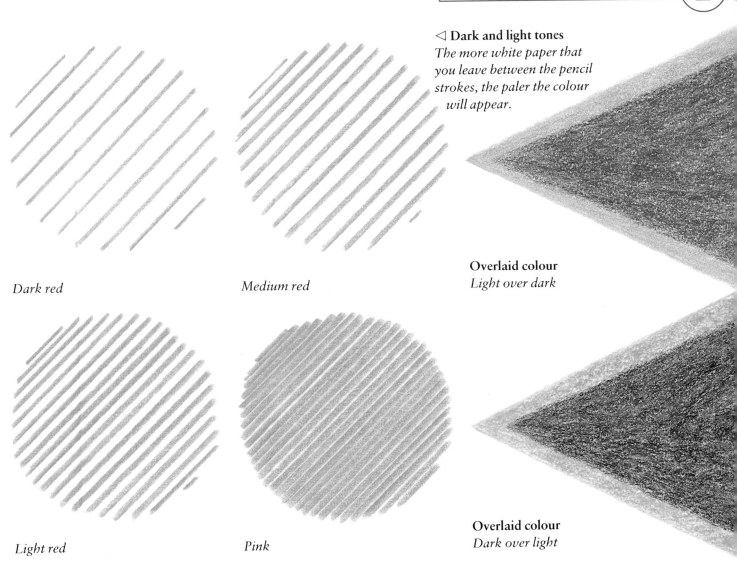

Dark red

Medium red

Overlaid colour
Light over dark

Light red

Pink

Overlaid colour
Dark over light

You can optically mix as many colours as you like, but the more you use the more neutral and subdued the result becomes; the colours cancel each other out. Yet there are exciting possibilities. You can modify crude colours – produce a basic green, for instance, from blue and yellow, then add a few spots of pink, purple or any other colour to tone it down, warm it up or make the green harmonize with other colours.

Dark tones
There are limits to how many layers of colour the paper will take and the transparency of coloured pencils tends to work against building up very dark tones. So use a dark pencil – black, dark grey, brown or a dark tone of any colour.

Again, remember that a dark colour on top of a light one tends to overpower the colour underneath;

and black on any colour will produce a near-black. But if you apply the dark tone first, the overlaid colours are generally more visible.

Lights and whites
As with watercolours, the whiteness of the paper can be used as white. For highlights and other white areas, leave the paper blank. When overlaying, a pale tone can be achieved by applying the pencil lightly so the white paper shows through. In optical mixing, you can leave areas of white paper between the pencil strokes. Thus you could achieve pink with a red pencil by using either of the two techniques.

White pencil can be used, but it tends to brighten rather than lighten the underlying colour. If the underlying colour is heavy or bright to start with, a white pencil on top can make almost no difference.

17

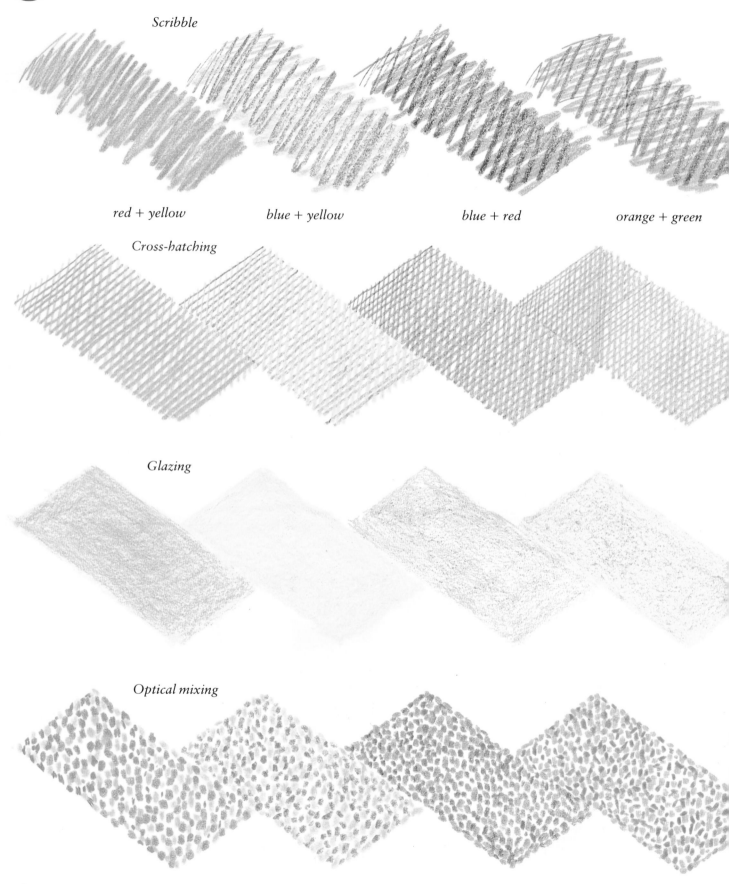

Scribble

red + yellow blue + yellow blue + red orange + green

Cross-hatching

Glazing

Optical mixing

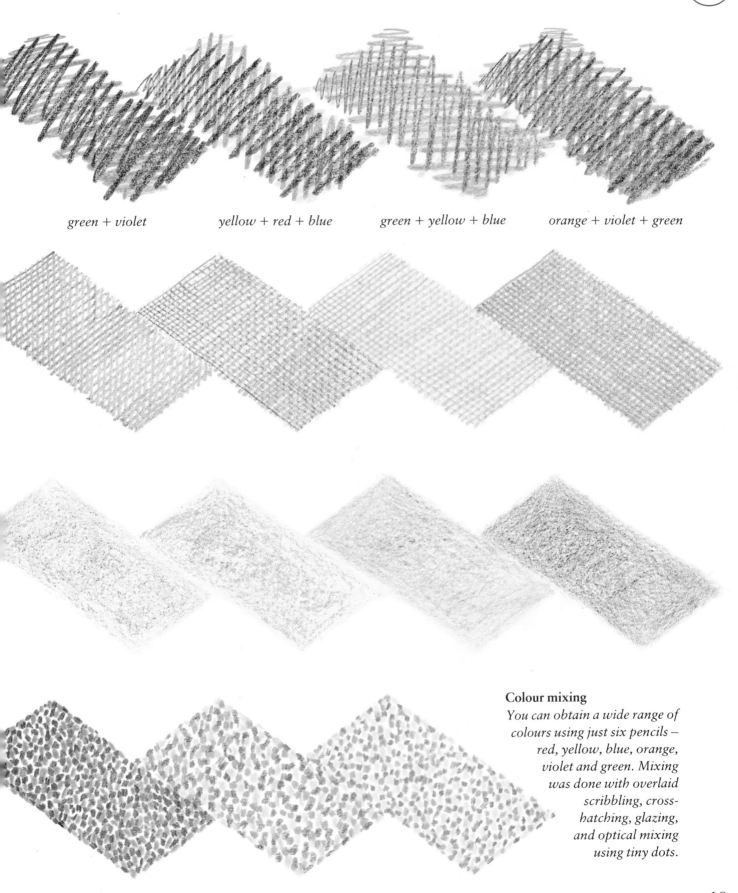

green + violet *yellow + red + blue* *green + yellow + blue* *orange + violet + green*

Colour mixing
You can obtain a wide range of colours using just six pencils — red, yellow, blue, orange, violet and green. Mixing was done with overlaid scribbling, cross-hatching, glazing, and optical mixing using tiny dots.

Pencils and paper

●

Drawing pins

Sharpener

Paper

Scalpel

THE MATERIALS you need are the simplest, cleanest, most convenient and mobile of all the artists' media. This is an overwhelming advantage for the beginner, who does not have to worry about palettes, pots of water and turpentine, and need not seek a large workspace and storage area. Basically, you will need pencils and paper, and a few accessories. A drawing board is a good idea – but it need not be cumbersone or even purpose-made. Plywood or hardboard is a good alternative.

Pencils need regular sharpening. Ordinary sharpeners or craft knives are suitable. For very precise pencil points, some artists prefer a sandpaper block – pads of sandpaper which come in different sizes; when a fresh sandpaper surface is needed, simply peel back the worn one.

Erasing the marks of coloured pencils is not impossible, but erasers are used as much for blending as for making the marks disappear. Another blending tool is the torchon – a pointed stump, often made of tightly rolled paper.

There are some optional extras. Holders are available for extending the lives of shortened coloured pencils. And the pencils themselves can be supplemented by coloured sticks which make chunkier marks. Some manufacturers produce these to match exactly the colours of their pencil ranges.

●

Watercolour pencils

Erasers

Cotton buds

Paper

Sandpaper block

Coloured pencils

Pastel pencils

Brush

CHOOSING PENCILS

Avoid the hard, scratchy coloured pencils which you might have been given at school. It is important to go for quality right from the start.

Roughly speaking, coloured pencils can be divided into two categories: the 'student' type, which is used in many schools; and the 'artist' type. Use the latter.

'Artist' coloured pencils produce superior colours, smooth and bold, and contain none of the impurities which cause scratches on the surface.

The pencils come in hard and soft varieties, and many artists use both, choosing the harder ones for sharply defined lines and detail. Quality hard pencils should not be confused with the hard pencils which you may have used during your schooldays; your hard pencils should be capable of intense colours as well as sharp lines.

The softer varieties, producing an effect rather like soft pastels, are used for shading and producing more feathery effects of tone, colour and line.

Start with a few

Coloured pencils are sold individually and in sets. Some of the sets are impressive; they often come in a range of seventy-two colours and are beautiful possessions. However, you are not advised to rush out immediately and buy one.

For beginners, it is better to start with a few pencils in varying degrees of softness and gradually build up a collection of the colours you want. As the softness depends on brand, you will find that a

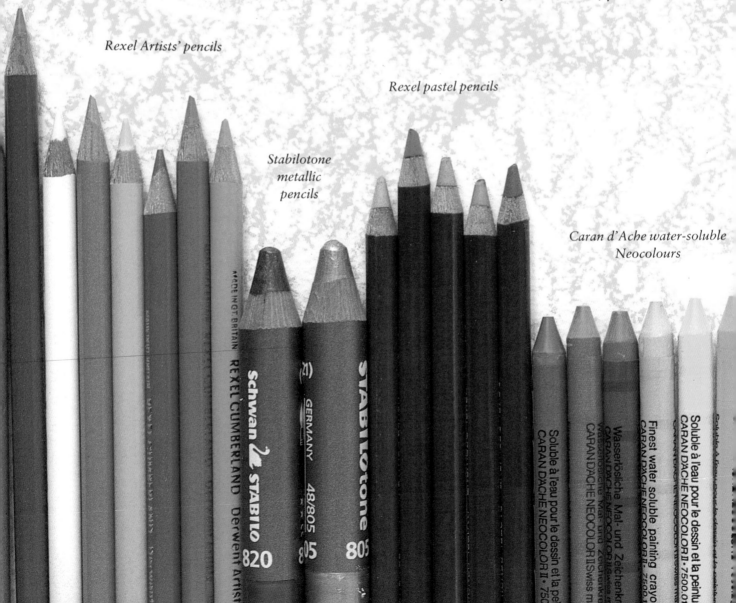

Rexel Artists' pencils

Stabilotone metallic pencils

Rexel pastel pencils

Caran d'Ache water-soluble Neocolours

set contains pencils that all have the same degree of softness. It is best to become acquainted with the properties of various brands before making an investment in larger quantities.

The brands

Quality pencils include Prismala, made by Caran d'Ache; Faber-Castell; Derwent, made by Rexel; Conté; and Schwan. Conté pastel pencils and the Schwan Carb-Othello range are very soft.

Most manufacturers make a water-soluble range, which can be used to produce an effect very like watercolour paints. It is also possible to obtain coloured pencils which can be used on film and acetate. These include Kohinoor's Projecto-colors and Chinagraph.

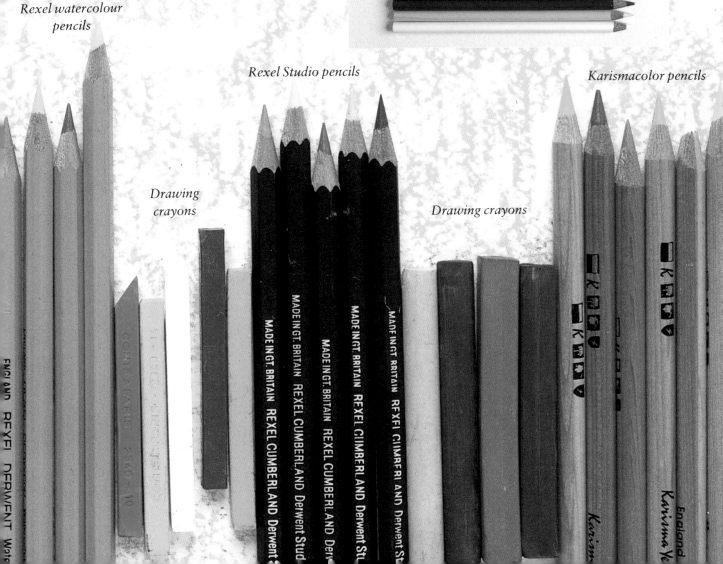

Rexel watercolour pencils

Rexel Studio pencils

Karismacolor pencils

Drawing crayons

Drawing crayons

MAKING PENCILS

The coloured core of a pencil is made from clay. The colour itself comes from pigments which are mixed into the clay with gum in order to bind it. The mixture is made into a solid block which is then forced through a hole to produce a long spaghetti-like tube that can be chopped into pencil-length pieces. For several hours, the pieces are soaked in wax to give the final pencil its smoothness.

The pictures here show Cumberland pencils being made at the Aco-Rexel factory in Cumbria, northern England. The raw materials have been imported from all over the world. Most of the clay comes from Germany and Britain. The gum is brought from the Middle East and the wax from Brazil, Japan and eastern Europe. The pencil's wood is from the Californian cedar tree – soft, with a straight grain – which is cut into pencil-length slats and grooved. Each core is placed into a grooved slat and glued. Another grooved wooden slat is clamped on top, to make a 'sandwich'.

A major problem

Manufacturers of coloured pencils face the tricky problem of how to maintain consistency. The artist wants to buy a colour which is exactly the same as one previously used.

By checking and weighing the pigment and all the other ingredients, the makers aim at guaranteeing that a certain red, for instance, will be identical to the same red which may have been bought several years earlier.

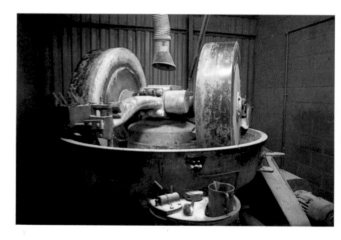

△ 2 *The powdered pigments are ground until smooth in huge metal mills.*

▽ 3 *Coloured pencil cores are immersed for several hours in hot wax.*

△ 1 *Pigments, selected and tested and ready to be used in coloured pencils.*

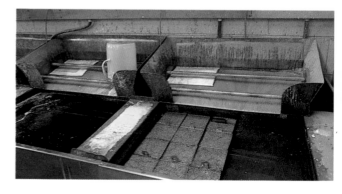

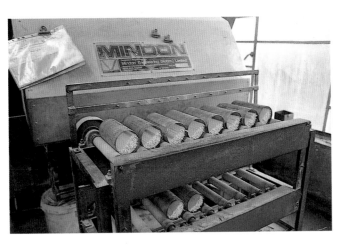

◁ **4** *The cores are dried in rotating cylinders to prevent them from warping.*

▽ **5** *Cores are stored according to colour ready to be put in their wooden holders.*

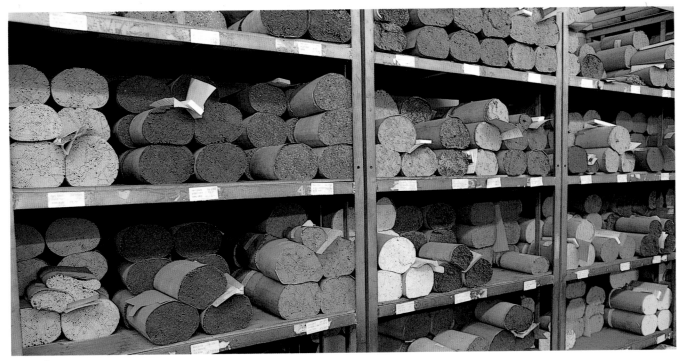

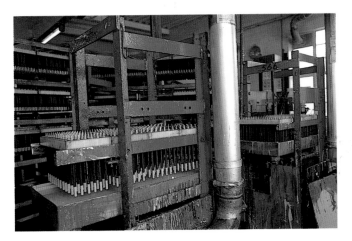

△ **6** *Finished pencils are painted by being dipped in the appropriate colour.*

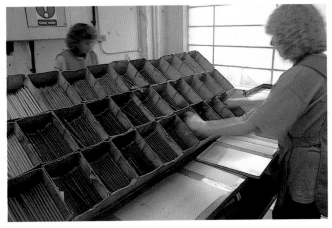

△ **7** *The coloured pencils are sorted by hand, then packed in sets.*

CHOOSING A SURFACE

Most paper surfaces have a certain amount of 'tooth' – a texture to which the colours can adhere. This texture will play a key role in your choice of surface. If you wish to use the softer range of pencils, you will probably find that a more toothy texture is desirable. Harder pencils can be used on smoother surfaces.

In fact, there is no paper specially made for coloured pencils. The coloured pencil artist ususally chooses from cartridge paper – a drawing paper – and surfaces made for pastels or watercolour paints.

There is a limit to how smooth a paper can be before the colour adheres effectively. Papers with a coated or polished finish will tend to produce poor results even with hard pencils. However, you should experiment. This is part of the enjoyment of using coloured pencils. As a general rule, smooth papers are suitable only for hard pencils; and remember that rough papers are not good for detail.

Machine-made

Machine-made papers, which have an evenly textured surface and are cheaper than the hand-made versions, are often referred to as 'hot-pressed' and 'not'. Smoothness is produced by hot-pressing during the manufacture. Thus 'hot-pressed' or HP papers have less key or tooth. Papers which have not been hot-pressed – 'not' papers – have a granular surface and produce equally granular drawings.

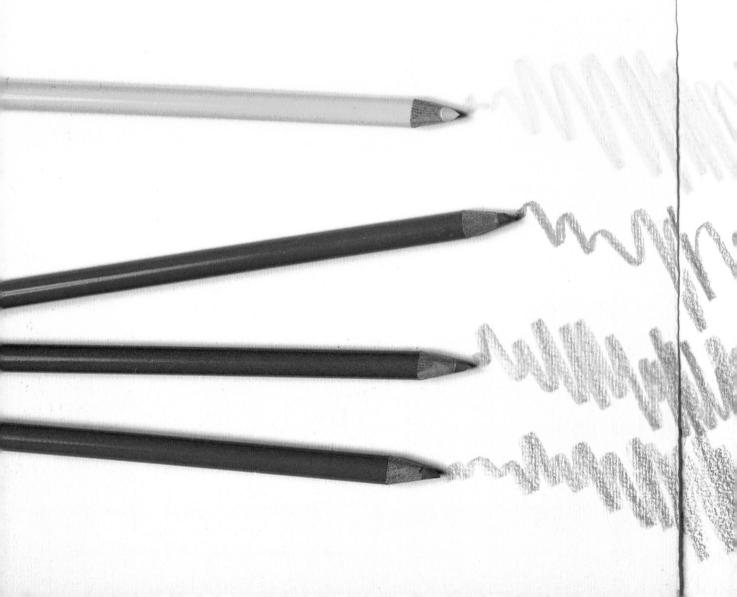

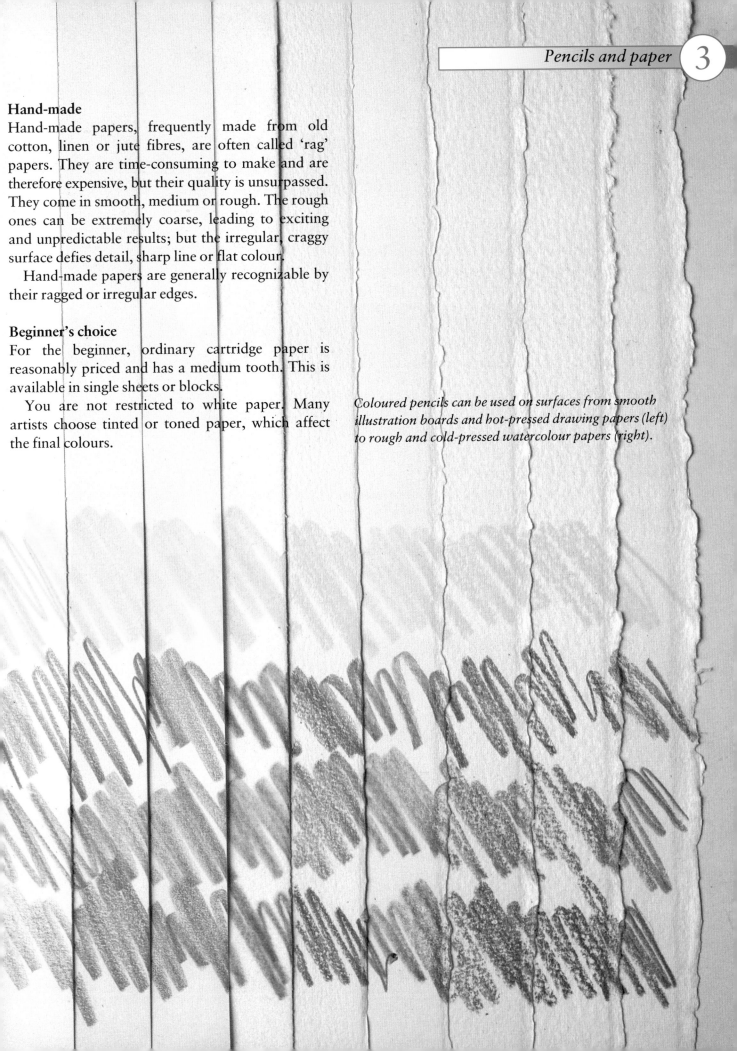

Hand-made

Hand-made papers, frequently made from old cotton, linen or jute fibres, are often called 'rag' papers. They are time-consuming to make and are therefore expensive, but their quality is unsurpassed. They come in smooth, medium or rough. The rough ones can be extremely coarse, leading to exciting and unpredictable results; but the irregular, craggy surface defies detail, sharp line or flat colour.

Hand-made papers are generally recognizable by their ragged or irregular edges.

Beginner's choice

For the beginner, ordinary cartridge paper is reasonably priced and has a medium tooth. This is available in single sheets or blocks.

You are not restricted to white paper. Many artists choose tinted or toned paper, which affect the final colours.

Coloured pencils can be used on surfaces from smooth illustration boards and hot-pressed drawing papers (left) to rough and cold-pressed watercolour papers (right).

COLOURED PAPERS

If you use yellow coloured pencil on a blue coloured paper, you will end up with a yellow that has a greenish tinge. Use the same yellow on a red or rust coloured paper, and the final colour will look orange. The colour of the surface has a vital effect on the end product.

Depending on the colour you use, the paper underneath can make it look more or less intense. The paper can also alter the colour's temperature.

More obviously, the tone of the paper affects the tone of the picture – a dark paper produces a darker overall effect.

Artists, therefore, choose coloured papers for two basic reasons. First, they choose a surface colour as part of the overall colour scheme of their picture. For instance, a predominantly green landscape can look more effective if you work on a complementary red background. Second, they pay careful attention to the tone. Many, for instance, prefer to start work on a medium- or mid-toned surface, against which all the highlights and dark shadows show up.

The points above demonstrate that you are not by any means confined to white paper. The choice of paper can be as creative and important as the choice of pencil. A wide range is available, including any of the papers used mainly by pastel artists such as Canson Mi-Teintes and Fabriano.

The colour of the paper dictates the colour of the mark you make. This illustration shows how the three primary colours are affected by the underlying colour of the paper.

Projects with pencils

HERE IS no clearly defined line where one patch of colour ends and another begins on the thick, sleek fur of the sleeping cat you will encounter on the following pages. The landscapes, too, look daunting at first, with their stonework and trees and tangled foliage. And is there a way of depicting distance with pencils? How do pencils mix with other media, such as watercolour paint? These are some of the questions which our artists tackle in the projects coming up, each one of which is linked to a particular technique as it progresses clearly, step by step.

The projects begin with the straightforward cross-hatching technique, in which an ordinary bowl of onions – a simple still-life – is given rounded depth and colour. While the cat sleeps, you are introduced to blending and burnishing as a way of capturing the patterns and colours on her coat. We demonstrate glazing, in which thin layers of colour are overlaid, and show how to tackle the complexities of landscape and perspective with simple strokes. The projects also cover the portrayal of detail, such as the colour, form and reflected light of fruit and flowers.

As you progress with coloured pencils, you may be tempted to use them alongside other media. Some of the projects demonstrate this. They also make use of different types of paper, both white and toned.

This striking menu design in red, yellow and blue demonstrates how directness and simplicity often achieve the best results. Designer Pippa Howes divided the illustration into four irregular shapes, providing her with an unusual and interesting starting point.

TECHNIQUES

BLEND, BURNISH AND ERASE

Coloured pencils are capable of producing such smooth, slick effects that a drawing can be made to look almost like a coloured photograph. In the hands of an expert, the results are impressive.

First, ask yourself if you really want to re-create a coloured photograph. If you do – and you should certainly explore the techniques involved – then

△ *Glazing*
◁ *Cross-hatching*

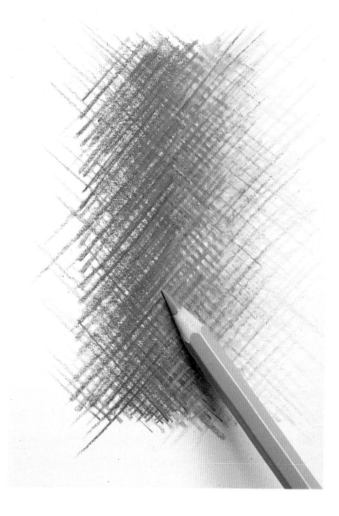

beware! This realistic blending can seem like an easy option, but a slick finish will not disguise a bad drawing. If the basic structure is wrong, no amount of blending will remedy or hide the fact. The result will look rubbery and flat. With a good drawing, however, you can take the next steps.

Blending and burnishing
These two processes are similar. Blending is when two colours are merged or fused together so that you cannot see the join. This is usually done by applying pressure to the pencil and overlapping two dense areas of colour. Where the overlap occurs, a third colour will result – so smoothly mixed that it looks like a colour in its own right and you cannot pick out the two colours that went into its making.

Burnishing is the application of a light colour

with some pressure over areas of darker or brighter colour. This causes a blending or 'smoothing' effect; it can also make the original colours look brighter.

Torchons and erasers

It is more difficult to erase coloured pencil marks than to get rid of graphite pencil. If the marks are light and you use a clean, kneadable eraser, than erasing might succeed. More often, however, the eraser is used for blending or for lightening an area of colour.

An alternative blending tool is the torchon or 'stump'. You can make your own from tightly rolled paper or buy a ready-made one from most art shops. The torchon enables you to blend and smooth colours together. Its point allows you to

▷ *Optical mixing*
▽ *Burnishing*

work into tight corners and other areas to achieve a precision result.

Smooth colour mixing

Pencil colours can be mixed by overlaying the pencil strokes in different ways. Usually this is done by building up layers of neatly hatched and cross-hatched lines; with layers of thin, overlaid glazes; or with densely applied dots and dashes. All of these techniques can be adapted to achieve a smoothly blended or burnished effect, either by using a torchon or eraser, or by applying the initial strokes heavily and deliberately in order to merge one colour into another.

A word of warning: blending and burnishing produce a smooth, smudged surface finish which often disguises the texture of the underlying strokes, so making the strokes unrecognizable. This can have a deadening effect, and for this reason the smoothing-out process should not be overdone.

33

TECHNIQUES

SHADING

To the eye, flat objects are made three-dimensional by the way the light falls upon them, creating shadows and highlights. With coloured pencils, it is usually shading which describes how the light and shade fall on a three-dimensional object.

We have seen how colours can be mixed by overlaying, cross-hatching, glazing and loose scribbling. The same techniques can be used for shading.

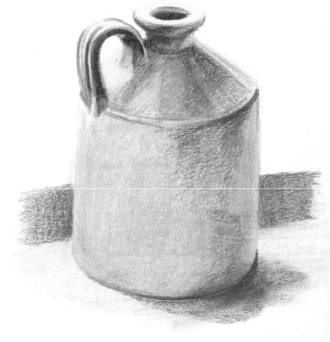

△ *Glazing*

◁ *Cross-hatching*

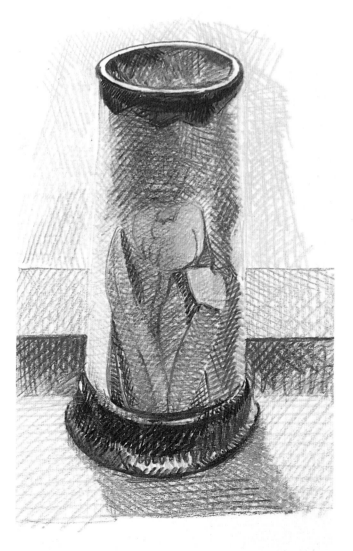

In the project illustrated here, the artist has drawn four similar objects, using a different technique in each case.

The first drawing has no shading at all. It is a depiction of a three-dimensional object, but done purely with a line drawing. Because we are familiar with the object itself and know it is three-dimensional, and because the artist has used the lines themselves to describe the form, the result is solid and real.

The other three drawings employ various overlaying techniques to describe the three-dimensional nature of the objects. The forms and volumes within each subject are described more specifically. We can see the highlights and the shadows thrown by the objects. In other words, we can see how the light falls on the objects and the direction from which it comes.

Tone and colour

The 'local' colour of an object is the actual colour, unaffected by light, shade and reflection. If you are

drawing a shiny red cup, the local colour is red. In reality, however, the cup has reflections and shadows, and picks up the colours of its surroundings. When drawing the red cup, therefore, a red pencil alone is not sufficient.

If you are working on white paper, the paper itself, as we have said earlier, can be used to represent the brightest highlights. Otherwise, you will need other colours, dark and light, to indicate the reflections and shadows on the red cup.

▷ *Optical mixing*

▽ *Scribble*

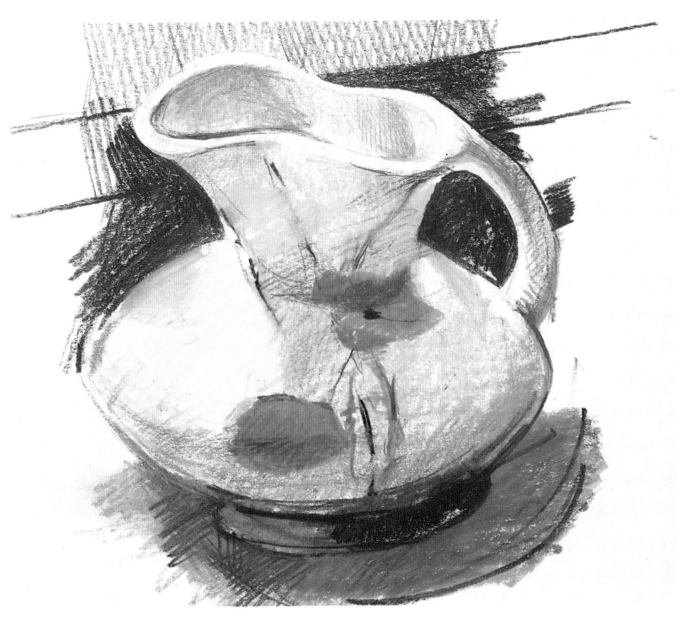

PROJECTS

BOWL OF ONIONS

Cross-hatching

A simple still-life is ideal as a subject for a beginner. It neither moves nor changes. These onions on a breadboard fit perfectly into this category. They form a 'logical' subject, in the sense that the picture can be built up, step by step in your own time, letting you control what you are doing. The local colours – the colours of the subject itself, unaffected by light or reflection – are warm browns, pinks, yellows and oranges. The shadows demand cooler, darker tones, such as deep blues and purples.

The simplest, most controllable way of building up tone and colour with coloured pencils is cross-hatching. It allows you to overlay the colours so that you get a mixture without obliterating any individual colour. Here, the artist has drawn hatched lines of warm pinks, browns and ochres to establish the basic onion colour. For the shadows on the onion, he has cross-hatched the darker, cooler tones on top.

Using cross-hatching means that the cools and warms actually mix. The technique has given a continuity to the subject: form has been described by establishing the areas of light and shadow, while the underlying colour remains visible overall.

White highlights

Coloured pencils do not easily lend themselves to working from dark to light – that is, if you draw a lighter colour on top of a darker one, the darker colour will always show through. To produce the white or near-white highlights on the onions, where light is falling most intensively, you have to leave parts of the paper showing through. The artist has chosen a white paper for this reason.

You can grade the tones, making them deeper as they recede away from the highlights, by using progressively denser cross-hatching.

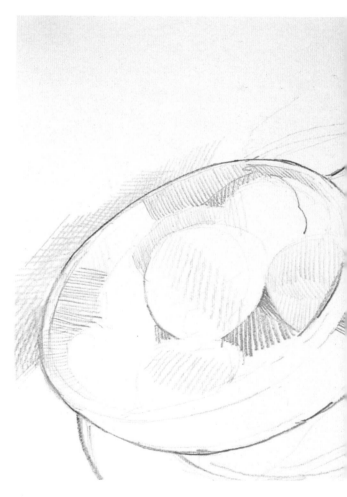

△ **1** *The onions, bowl and board are warm in colour – mainly yellow, orange and brown; the cloth and the shadows are generally cooler and darker.*

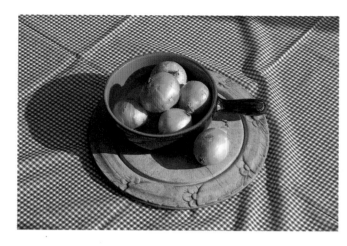

△ **2** *The outline drawing is done in brown, blue and reddish brown – the local colours of the subject. Initial colours are blocked in with hatched lines. Shadows are blue; the onions and bowl are warm browns and ochres.*

▷ **3** *Darker colours and tones are created by overlaying the hatched lines. Here the artist builds up the brown of the bowl with a second layer of hatching.*

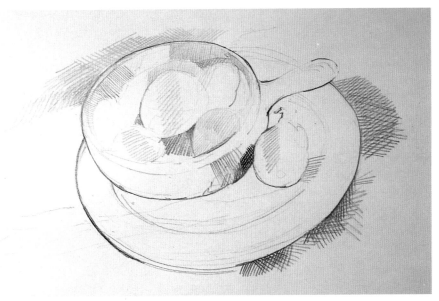

△ **4** *At this stage the main local colours and some of the darkest tones have been established. Plenty of white paper has been left to represent lighter tones.*

◁ **5** *Colours are mixed by overlaying two or more pencil colours. Here, pale grey is used to tone down the ochre and brown mixture on the wooden board.*

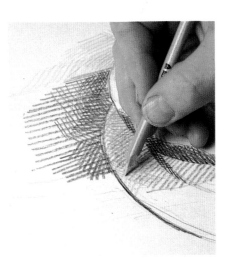

37

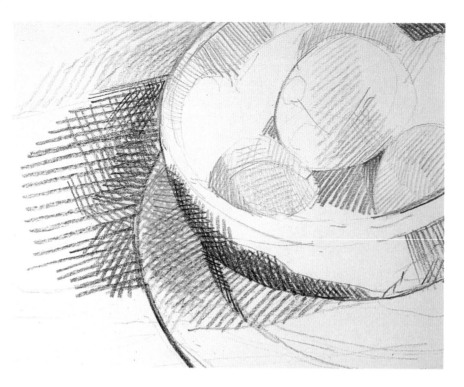

◁ **6** *Pencil strokes are straight and regular and are applied in small patches, or planes; the strokes themselves do not curve or follow the rounded forms of the subject.*

▽ **7** *Still working in small patches, the artist works across the drawing, developing colours and building up tone. Dark shadows on the onions and bowl are hatched over the warm local colours.*

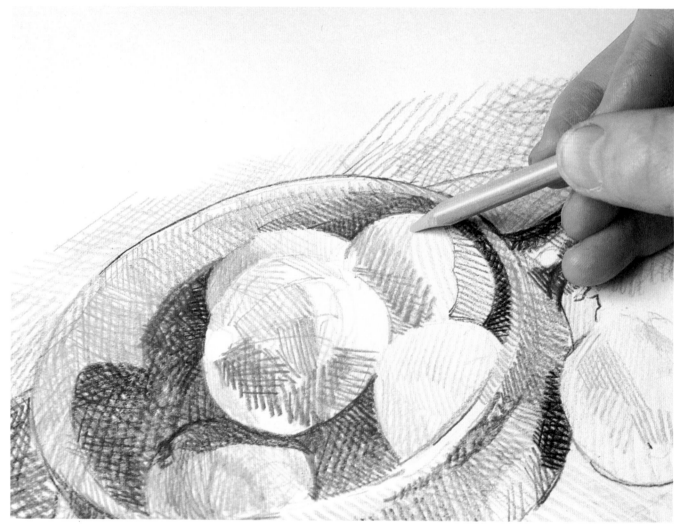

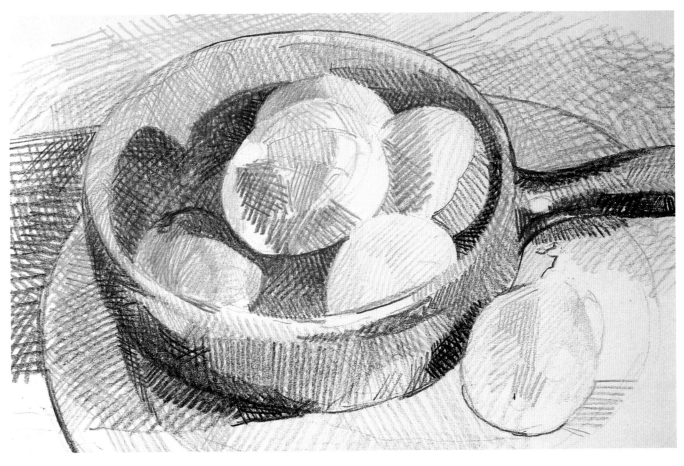

△ **8** *The artist has carefully preserved areas of white, some of which will eventually be lightly hatched to create highlights and reflections.*

▷ **9** *The drawing is nearing completion as the artist continues to build up pencil strokes to create comparatively solid areas of tone and colour. Here, the rim of the bowl is described by adding a dark blue shadow.*

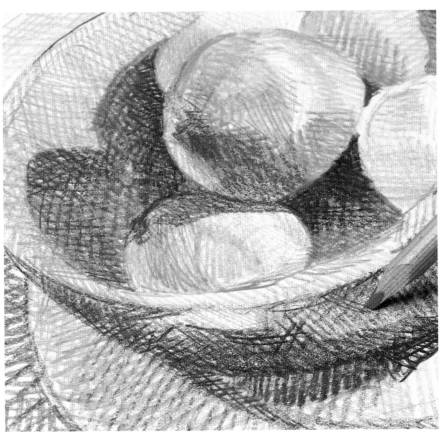

▷ **10** *The finished still-life was done using a limited range of pencils, including pinks, yellows, browns, reddish browns and ochres for the local colours with brown, blue and purple for the shadows. Patches of untouched white paper represent smaller highlights and reflections. For the near-white and very pale colours on the onions, the artist has lightly hatched white paper areas with pink and ochre.*

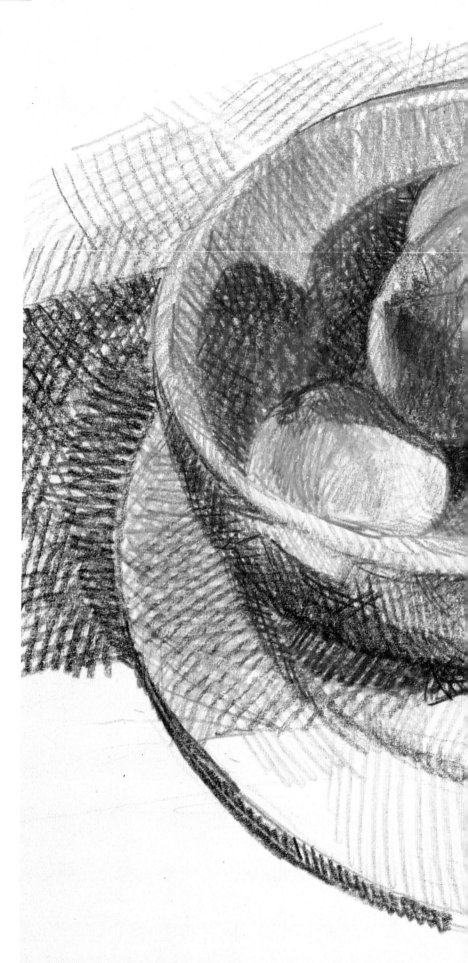

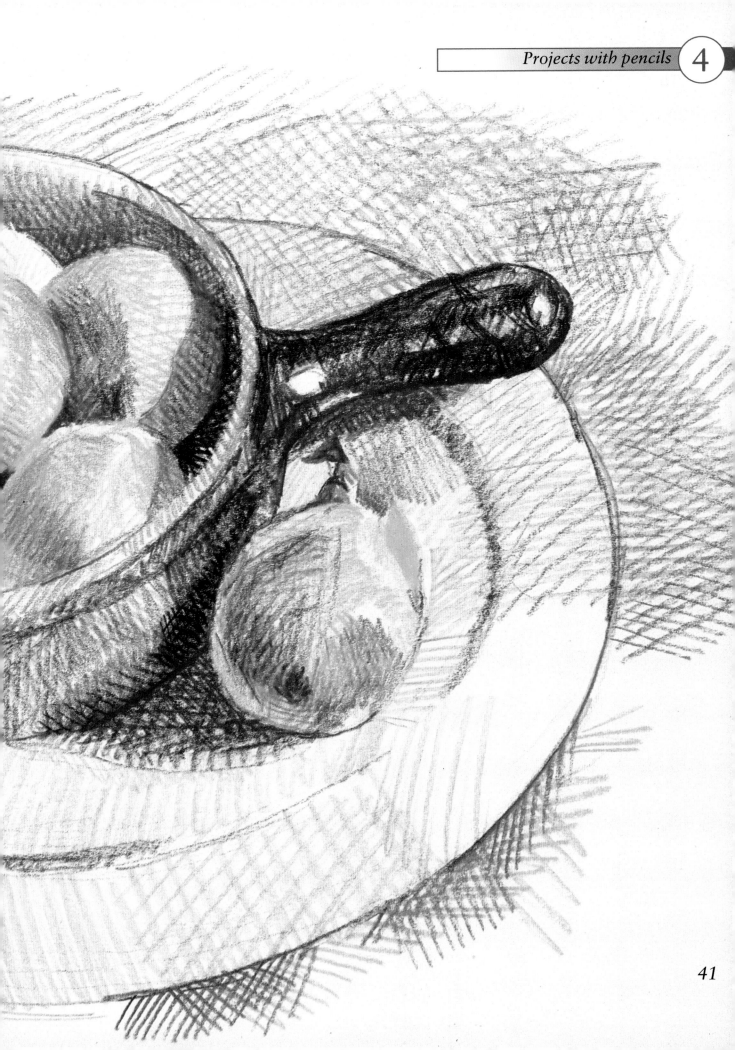

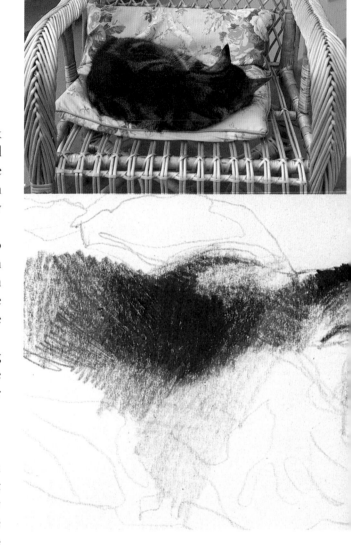

PROJECTS

SUZIE THE CAT

Blending and burnishing

Suzie is ageing with dignity and possesses a sleek coat whose patches of ginger and black blend together in a tortoiseshell pattern. Being a cat, she has ignored the artist and curled up for an afternoon nap in the conservatory, unwittingly presenting an opportunity for a quick drawing.

Animals make wonderful subjects, but they do not always co-operate. This project was done from life, but if you cannot make a quick picture, plan for several separate sittings if the animal has the habit of adopting the same position; otherwise work from preliminary sketches or photographs.

The cat was a perfect subject for the blending technique. The dark and light patches of coat were not divided by clear lines. The texture of the fur was such that one colour 'grew' into another.

Solid colour

Starting from a light drawing, the artist shaded with dense, close strokes. The dark, rich gloss of the coat called for solid treatment. The artist blended fairly dense areas of tone, one over the other, with close strokes, pressing quite hard. The boundaries were then burnished with a light-blue pencil to give shine and sleekness.

Blending the edges

Although light coloured pencils do not obliterate dark, the artist applied dark patches, then took the lighter patches right up to the dark ones. The colours were merged by pressing very hard with a lighter pencil, softening the edges to blend them.

The direction of the strokes was used to indicate the direction of the fur and help establish the form.

An animal, like a human being, is made up of subtle, round forms. These forms create internal contours within the main outline – contours which can be difficult to depict when working in outline alone. In this drawing, the artist uses directional pencil marks to describe the underlying structure.

△ **1** *The dark, sleek shape of the cat shows up clearly against the lighter tones of the flowered cushion. Her fur is dense with subtle highlights, and this calls for some equally dense pencil strokes.*

△△ **2** *A very light outline drawing allows the artist to ma* *alterations should the subject move slightly during the drawing. Dark fur patterns are established in close, dense strokes of black. The pale areas are lighter strokes of brown and yellow ochre.*

▷ **3** *At this stage, the black shapes join the pale areas, leaving a hard, unblended edge. These edges will eventually be softened by burnishing. The direction of the fur is emphasized by the direction of the pencil strokes.*

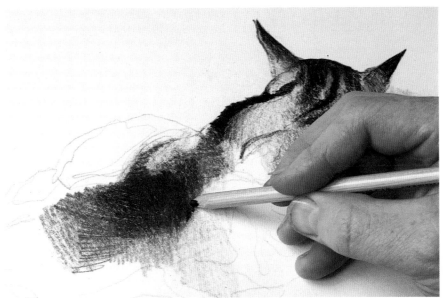

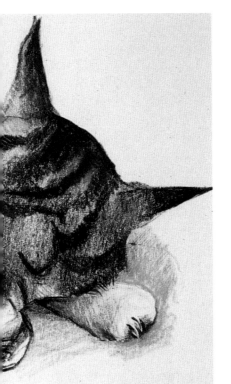

▷ **4** *Light blue is applied heavily, burnishing the black markings into the adjoining paler areas.*

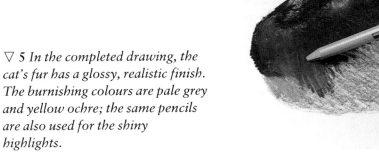

▽ **5** *In the completed drawing, the cat's fur has a glossy, realistic finish. The burnishing colours are pale grey and yellow ochre; the same pencils are also used for the shiny highlights.*

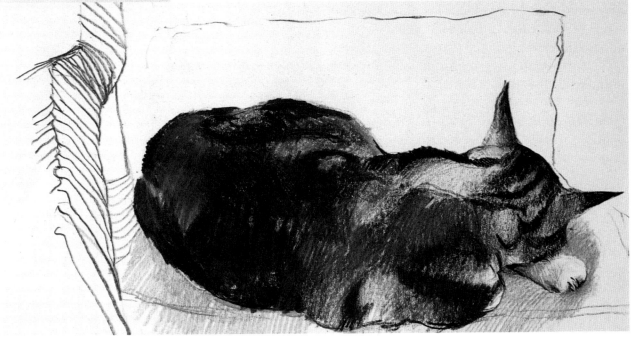

43

PROJECTS

AUTUMN APPLES

Glazing

In this arrangement, none of the apples is entirely one flat colour. Their reds and greens mix and reflect, and mottled patches appear on some of the rounded surfaces. This exercise in subtle tones lends itself to the glazing technique, using thin layers of overlaid colour. The approach here is slow, controlled and cautious, with constant observation. The artist begins light and continues light, applying colours and tones thinly on top of each other, building up the whole picture in gradual stages.

Smooth colour

The artist achieves a veil of colour rather than strokes. Using the side of the pencil tip instead of the point, you can produce broad areas of light colour and disguise the pencil strokes.

Beginning with a light line drawing, the artist lightly blocks in local colours – the reds, greens and some yellow. Cooler shadows are introduced in thin veils of overlaid colour. Then the artist moves across the whole image, alternating between shadows and local colour, building up tones correctly, never applying so much colour that it would distort the tones in the rest of the picture.

Planning highlights

Graded tones are used to describe the rounded shape of the apples. The glazing on the darker sides of the apples thins out gradually into pale and light areas, and eventually fades out altogether into white paper. These highlighted areas of white paper have been left uncovered from the start.

Keep the pencil sharp, so that you have more colour to play with when using the side. Hot-pressed paper was used, because of its smoothness. Coarse-textured paper would have worked against a smooth effect.

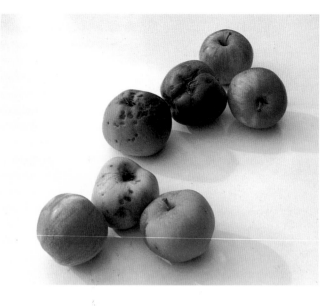

△ 1 *The subject was chosen for its colours – layers of reds yellows, greens, browns and purples glazed over each other to reproduce exactly the varied greens and rosy tones of the apples.*

▽ 2 *The drawn outline is minimal. Each apple is lightly sketched in its own approximate colour – red, yellow or green. Using the side of the pencil point, the artist begins to glaze some of the local colours.*

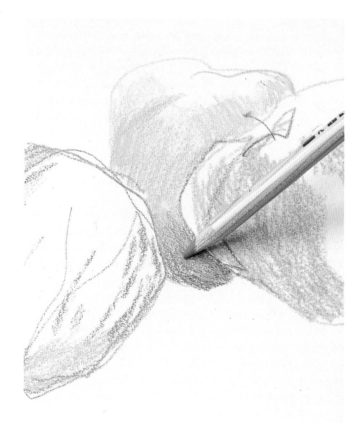

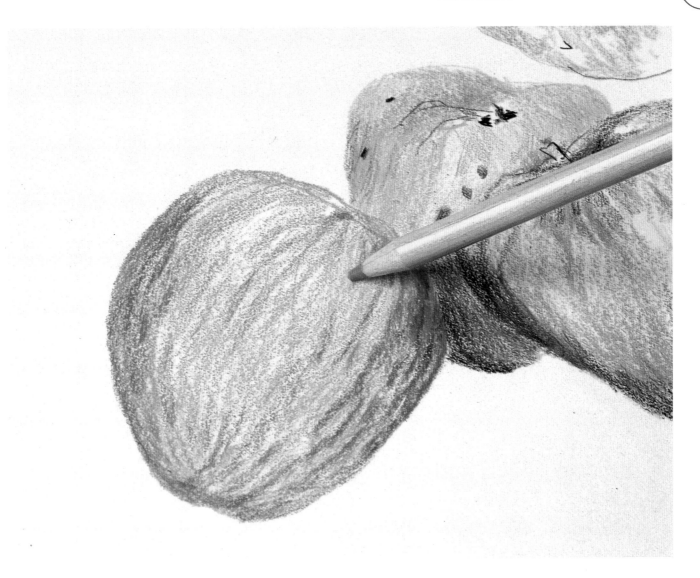

△ **3** *Still working with the side of the point, darker tones and colours are built up and developed. Markings and patterns on each fruit are rendered more heavily with the pencil point.*

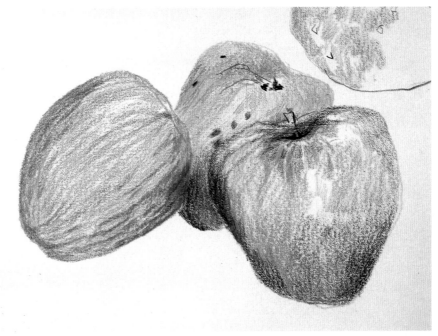

▷ **4** *At this stage, the basic colours of the first three apples are established. Darker shadows are left to the final stages, when the deep tones of the whole picture can be worked simultaneously.*

45

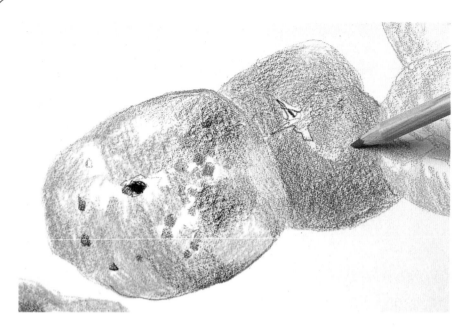

◁ 5 *The second group of apples is drawn in the same way – overlaid glazes of reds, browns, greens and purples to establish the local colours and indicate shadow areas.*

▽ 6 *The artist now starts to overlay the dark tones, using a black glaze on the shaded parts of the apples. Here, the same black glaze is applied to the shadows cast by the fruit.*

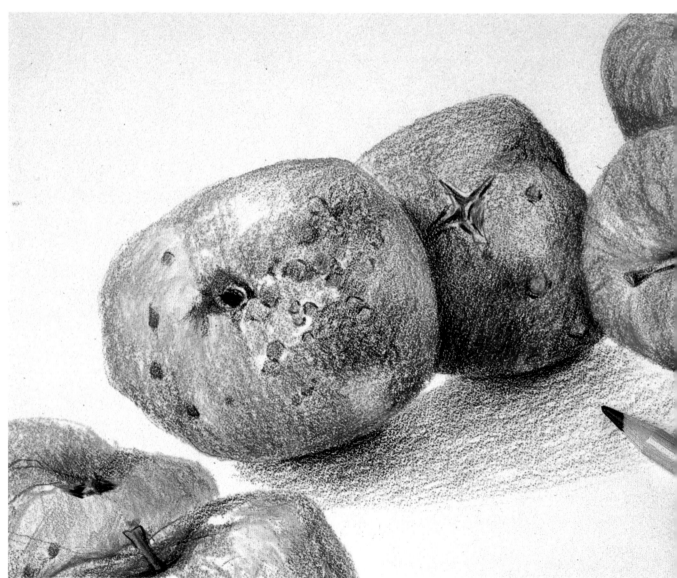

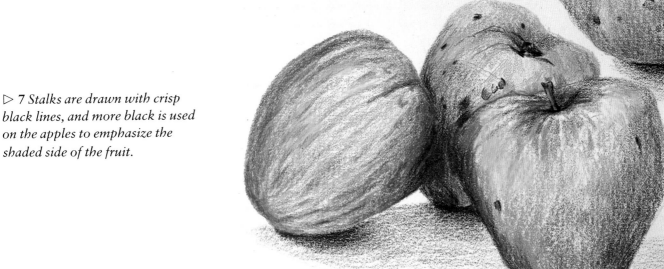

▷ 7 *Stalks are drawn with crisp black lines, and more black is used on the apples to emphasize the shaded side of the fruit.*

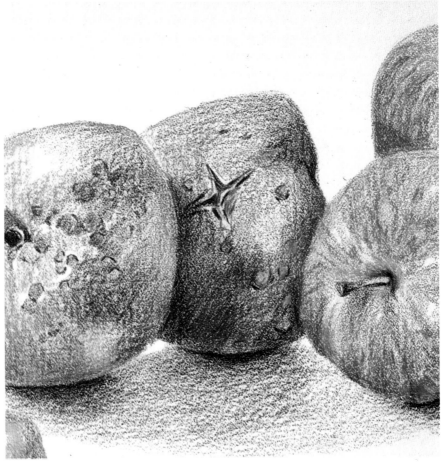

△ 8 *Mottled patches and markings on the fruit are glazed in black. The artist took care to keep these paler than the glazed black shadows.*

47

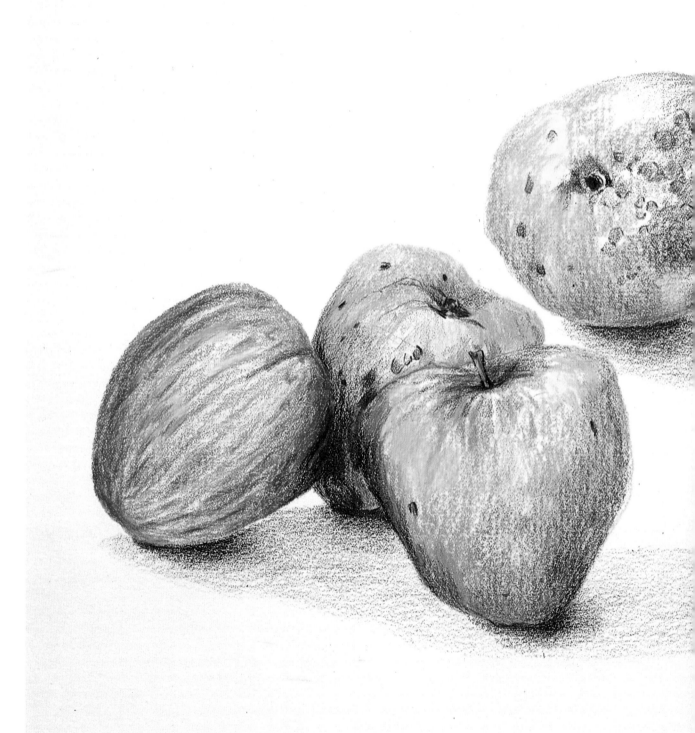

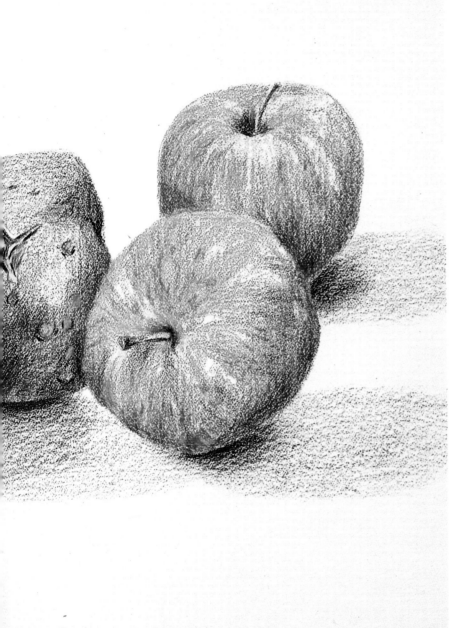

9 *Although black is the main shadow tone, it is never allowed to dominate other colours in the drawing. The overall effect is one of bright, natural colour. The artist has succeeded in creating a sense of space in the completed drawing by making the three foreground apples brighter and darker than the cluster of fruits behind them.*

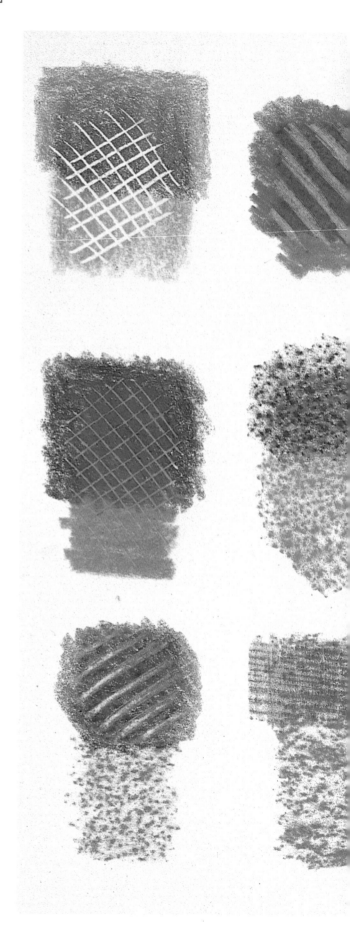

TECHNIQUES

SPECIAL EFFECTS

Coloured pencils can be great fun; it need not be all academic drawing. Do not think of the coloured pencil drawing as merely an attempt to 'imitate' the older media. Pencils do not produce the same spectacular and accidental effects that can be achieved with paints, particularly watercolours, but they have their own range of special effects. These are exciting in their own right and they justify experimentation; or they can be incorporated into drawings and more finished works.

Frottage

You probably remember rubbing a pencil over a piece of paper laid over a coin – one of the tricks of schooldays. Frottage is a similar idea, rather like brass-rubbing. With coloured pencils it is possible to get attractive, varied results. You can use the technique on wooden floors, woven textures, wicker-work, relief carvings and many more surfaces. The paper on which you have done the rubbing can be torn or cut up and used in collage.

The impressed line

This is an effective technique for creating patterns in your drawings, such as those found in lace, calligraphy, flower stems and so on. Cover your drawing surface with thin paper or acetate and apply heavy pressure with a sharp object. These impressed lines will remain white when colour is applied.

Sgraffiti

This means scratching back into layers of colour and it allows you to create beautiful effects. The results are impromptu; you cannot exactly control what happens. It is certainly worth experimenting, but take care. You have to work slowly and with patience, because it is easy to damage the paper.

50

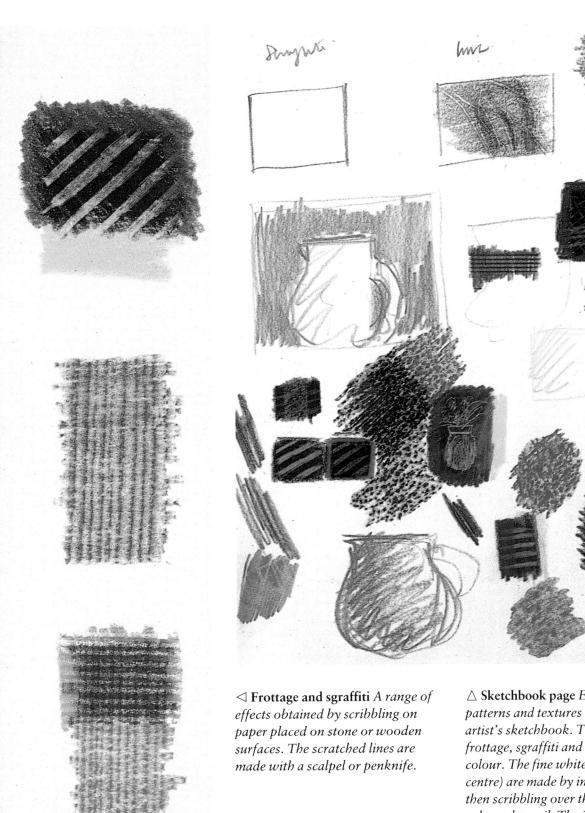

◁ **Frottage and sgraffiti** *A range of effects obtained by scribbling on paper placed on stone or wooden surfaces. The scratched lines are made with a scalpel or penknife.*

△ **Sketchbook page** *Experimental patterns and textures made in an artist's sketchbook. These include frottage, sgraffiti and overlaid colour. The fine white lines (top centre) are made by indenting a line then scribbling over this with coloured pencil. The indented line can be made by pressing hard with a knitting needle, blunt knife or other instrument.*

TECHNIQUES

TEXTURE AND PATTERN

We tend to take for granted the fact that we are surrounded by myriad surface patterns and textures. It is difficult to find a landscape that does not include at least some of the following – tree bark, sand, gravel, foliage, the changing shapes on the surface of water or a field of grass.

Many other patterns and textures around us are artificial. Created by people, these still play a dominant role in our everyday environment. They include things that perhaps surface only occasionally in our consciousness – the patterns made by bricks, stones and tiles, printed designs, textured papers and so on.

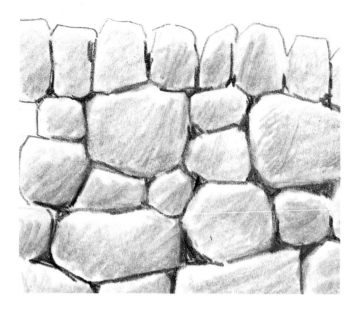

△ **Stone wall** *The outline of the stones was drawn in light grey, using short jerky strokes to create the jagged stone shapes. The stones were loosely scribbled in with grey, leaving a rim of white paper just inside the outline of each stone. Finally, the outline drawing is strengthened, and the gaps between the stones are scribbled in with dark grey.*

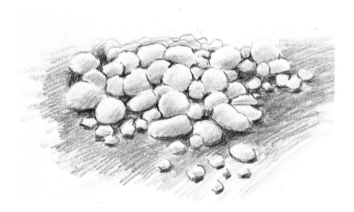

△ **Pebbles** *The artist used a simple formula to draw these pebbles: outlines were drawn in reddish brown and the same colour then used to scribble in the floor and shade the lower edges of the pebbles. Finally, dark shadow marks were added in deep brown along the base of each pebble.*

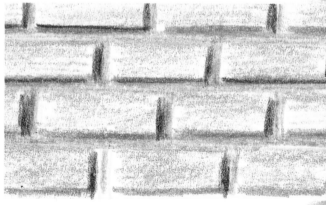

△ **Bricks** *The artist began with a very faint outline, then glazed each brick in light brown. A heavy line is drawn along the bottom of every brick to represent the shadow. The cement is drawn in grey in wide, even lines. Finally, a dark grey line is drawn around a few bricks to produce a more natural effect.*

Look at any of these and you will see that each is built up of hundreds of smaller elements – leaves, blades of grass, the individual bricks in a wall. For the artist, it is not only impossible but also inadvisable to include every unit. If you were to sit down to copy every leaf on a tree, you would have to remain there for hours and, worse, the rendered leaves would assume a prominence and clarity that real leaves do not have.

Copy or suggest?

The secret is to generalize, to find a formula that gives an impression of what you see. Half-close your eyes. Can you actually see the leaves on the tree? Or is it simply that you 'know' they are there? It is far more likely that your eye is picking up a roughly textured arrangement of light and shade. A pebble-dash wall looks more like the real thing if you suggest a few of the pebbles rather than trying to copy each one.

For centuries, artists have been developing formulas for simplifying complex textures. Look at drawings and illustrations; study the approaches used by different artists. You will find they are diverse, creative and often surprisingly simple.

Here, the artist has selected a few common, potentially complex subjects and found ways of making them simpler.

▽ *Stones, foliage and other textures can be effectively suggested using loose pencil strokes, as the artist has done in this landscape drawing.*

PROJECTS

THE SHEEP BRIDGE

△ **1** *Drawing out of doors, the artist came to terms with the constantly changing light by working at the same time of day over a period of a few days.*

Simplifying landscape

The dry-stone wall, the tree bark, the foliage, the grass – they all look complicated. But do not be daunted when confronting landscape. This picture demonstrates how you can use a simple, straightforward formula for rendering all these different textures and effects with coloured pencils.

The picture took two days to complete and was done methodically, built up in vertical lines.

Working on a toothy, textured paper, it started in the form of an outline in yellowish brown. All the tones and local colours were built up with the same regular strokes. Often three or four colours were overlaid. More than one colour was used for everything – a leaf, for example, was green plus blue in shadow or yellow in the light.

Shorthand

Short, downward strokes were used to build up the grass – lighter and shorter in the distance and more emphatic in the foreground. It was, in effect, a 'shorthand' for grass, and the same applied to the stone wall and foliage.

The stone wall was done in three easy stages. First, the outline was drawn. Then short, vertical strokes were used to fill in local colour. It began looking like a wall only when the artist entered the third stage, drawing stone shapes over the colour, using shading to help suggest the different stones.

Light changes constantly out of doors, so try to draw at approximately the same time every day for an hour or two. Sit on something comfortable and keep warm.

Use well-sharpened pencils and start off lightly, with local colour, gradually introducing tone. The first stages will often look fuzzy and out of focus. Don't be tempted to hone in straight away to define objects. Develop the whole image, gradually.

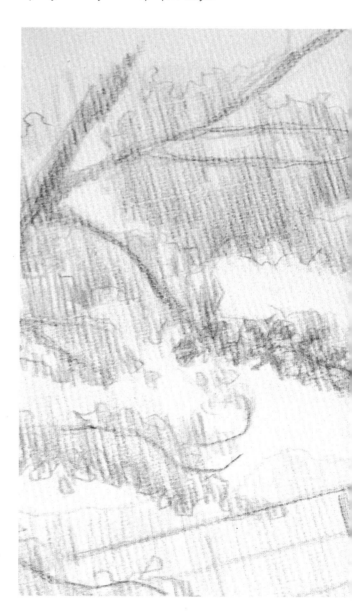

▷ **2** *The paper is Fabriano, which produces a pronounced surface texture when used with coloured pencils. First, the artist starts with an outline drawing in brown.*

▽ **3** *The first local colours and tones are blocked in using close, vertical strokes. Pencils are used lightly at this stage – eventually, each colour will be made up of two or more overlaid pencil colours.*

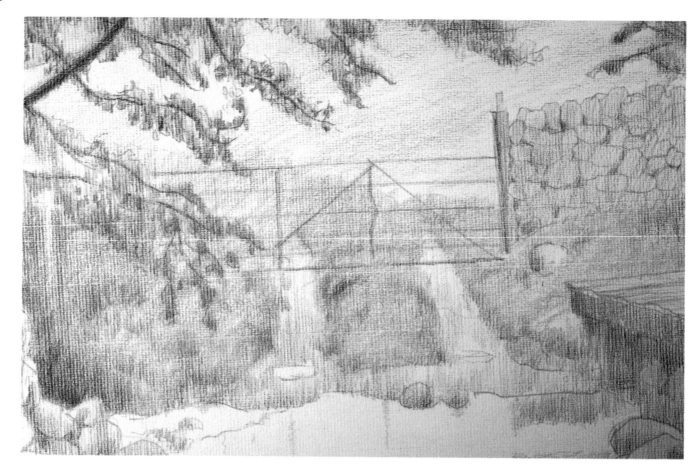

△ **4** *Light green is used for the grass, a darker green for the foliage. Each colour is laid in the same systematic, vertical strokes.*

▷ **5** *Grass and leaves are built up in overlaid shades of green. Here, the artist develops the dry-stone wall, using the outline colour to fill in the central areas of each stone.*

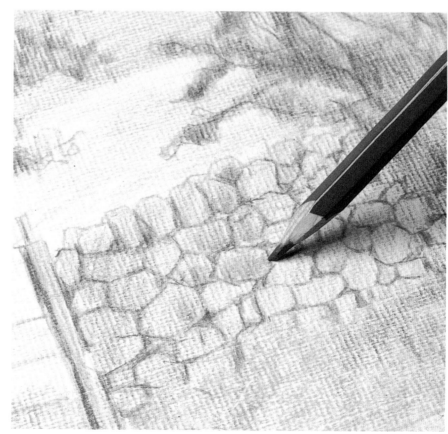

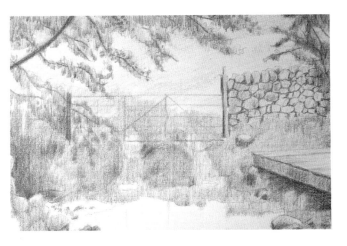

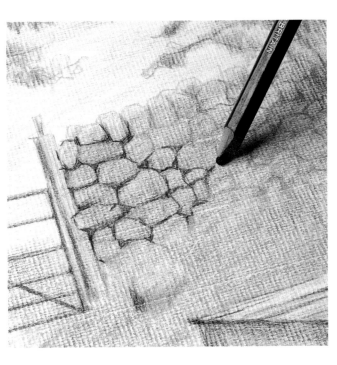

△ **6** *At this stage, the local colour and the shadow areas have been lightly blocked in. Every colour in the subject has been built up from two or more tones of the same colour. For example, the grass is not a single, flat green but is composed of three different greens.*

▷ **7** *The wall is sharply redrawn in black to indicate the deep shadows between the stones. A little extra shading is added along the bottom edge of each stone.*

▽ **8** *Dark shadows under the bridge are developed in black, grey and brown. The bridge itself is drawn and rendered in grey, brown, black and green.*

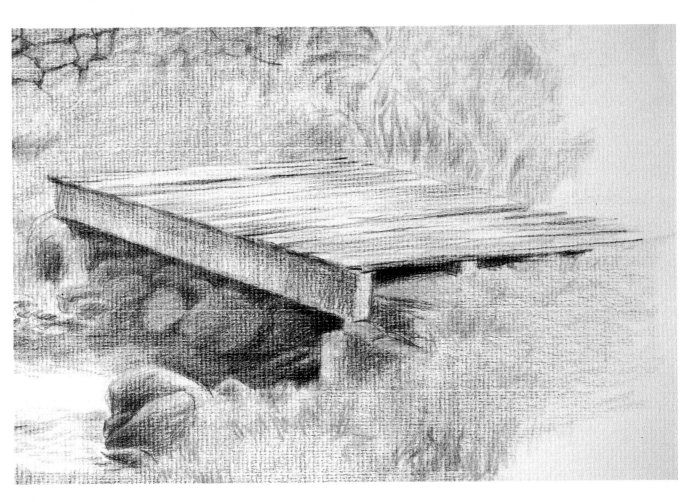

△ **9** *The artist is gradually building up related deep tones across the whole drawing. Subsequent dark areas will be related to these. At this stage, the wall and bridge are nearing completion.*

▷ **10** *Using a well-sharpened pencil, the artist draws in the finer tree branches with dark green. These are drawn in fine, delicate lines and the artist looks constantly at the subject in order to ensure accuracy.*

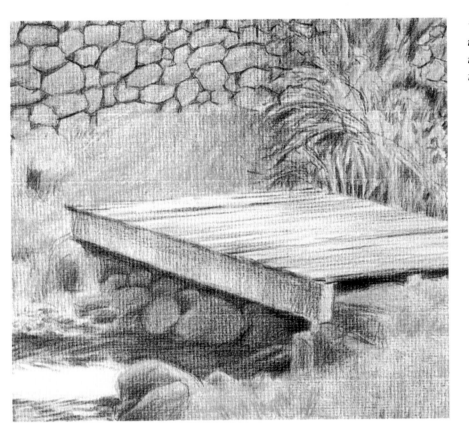

◁ **11** *Working gradually across the whole image, the artist continues to use dark colours to develop deep tones and add detail.*

▽ **12** *The drawing is now complete. Untouched white paper represents the light on the water; sky reflections are light blue; ripples and pebbles, drawn clearly and in detail with well-sharpened black and brown pencils.*

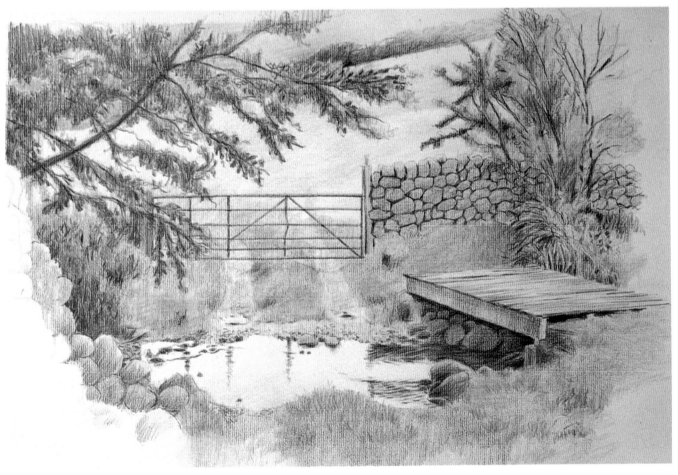

TECHNIQUES

WATERCOLOUR PENCILS

Somewhere between coloured pencils and watercolour paints are watercolour or 'water-soluble' pencils. They look exactly like coloured pencils and can be used as such, but because the pencil marks can be dissolved in water, it is also possible to create effects very like watercolour paints. This means that some of the advantages of watercolours – transparent washes and fluid effects – are available to the coloured pencil artist.

You can achieve these effects either by blending the colours with water after they have been applied to the paper or by first wetting the paper and then applying the colours. You can also dip the points of the pencils in water before drawing to achieve a dense, dark line.

Take time to practise

In theory, these pencils combine the transparency of watercolour paint with the linear quality of coloured pencils. In practice, they can be difficult to handle. You will need to spend some time experimenting with the individual colours before splashing water

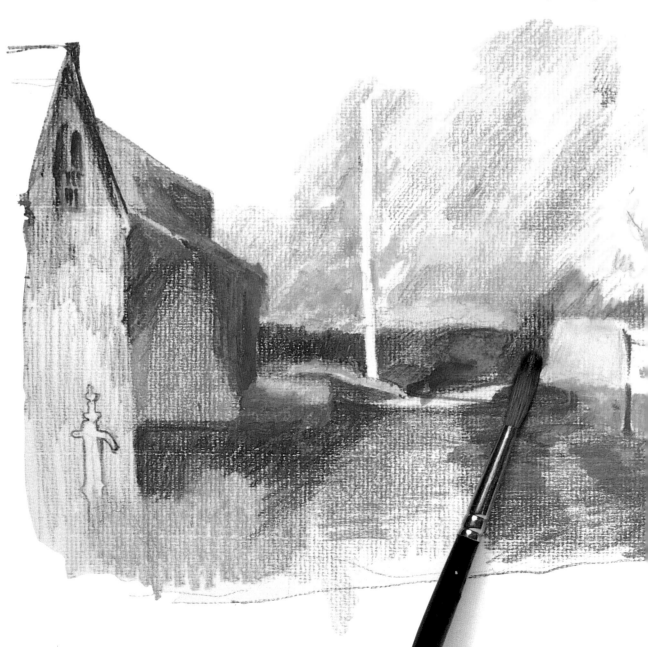

all over a carefully rendered drawing.

Water-soluble pencils are much loved by many artists, although some people cannot get on with them at all. One of the problems is that pigments darken when wet. Therefore, if you suddenly apply water to an area of carefully worked-out tones, that area will turn very dark – much darker than the tones elsewhere in the drawing. When the water dries, some colours are left very dark, some less so, and some pigments dry patchily. At their best, however, watercolour pencils successfully combine solid or transparent colour with line and texture.

Probably the most effective way of using these pencils is to make a complete drawing, then apply water to selected areas. Thus you retain control over the finished result. The real secret is to get to know the medium: test the pencils thoroughly so you know what to expect from each colour.

Water-soluble pencils *The pencils can be used to produce exactly the same marks and textures as any other coloured pencils. But with water-soluble pencils, colours can be dissolved to produce wash-like effects which look similar to watercolour paint. Here, the artist uses water on selected areas of a landscape drawing.*

PROJECTS

HERRING

Watercolour pencils

This is a combination of detailed drawing and transparent patches of pure colour – all done with pencils. The fish makes an ideal subject, because it has emphatic markings and yet, overall, it possesses a silvery, translucent quality.

Watercolour pencils can be used in different ways. You can, for instance, finish a drawing and afterwards dissolve selected areas with water, using a damp or soaked brush or cloth, or you can do what has been done here. In this case, the artist dissolved areas as she went along. This meant she could keep some lines hard and drawn. Where a watery, blended effect was desired, she went over the colour with a brush dipped in water.

The right paper

It is important to work on proper heavy watercolour paper. The surface must be strong enough to withstand the water; otherwise it will become overscrubbed by washes and start to disintegrate.

In this case, the subject takes up only a central part of the paper, but if you intend to do a lot of background washing, then you would be well advised to stretch the paper before you start.

The artist began with a light drawing, softening the internal contours with a brush. She continued alternating from pencil to water, gradually tightening up the drawing and introducing more colour.

For some of the darker lines, as the drawing neared completion, the artist dipped a pencil in water to get a more dense mark. Don't go for these hard lines until the rest of the tones have been build up and you know exactly where the strong lines should be.

Food, foliage and flowers soon lose their freshness in the hot or dry atmosphere of a studio, so here are a few tips: rub fish with olive oil to keep it shiny; use glycerine on fruit and vegetables; keep a water spray or diffuser handy to refresh wilting flowers and foliage or tired plants.

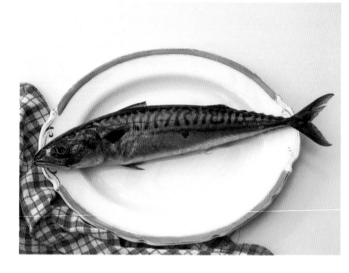

△ **1** *A herring contains intricate lines and patterns as well as areas of watery colour and silvery tone. It is an ideal subject for watercolour pencils.*

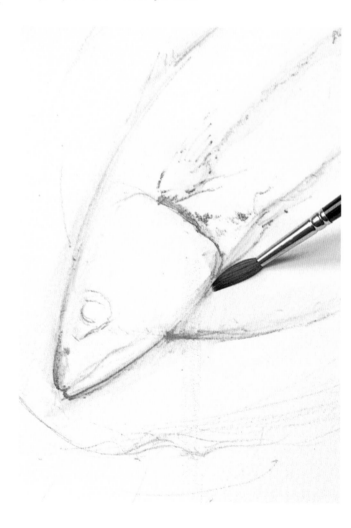

△ **2** *A loose, light drawing in blue and green pencil is dissolved with water to produce a soft, fluid outline.*

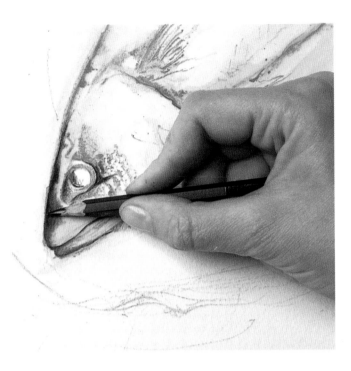

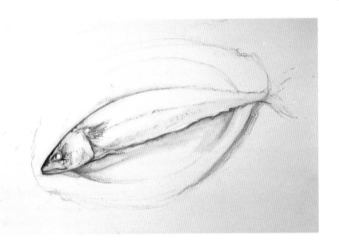

△ **4** *As the drawing develops, water is continuously brushed on to the pencil lines to keep them light and delicate. Observed colours, such as pink and green, are slightly exaggerated to enhance the overall effect.*

△ **3** *The fine, feathery lines of the head and gills are drawn in olive green, pink, brown and grey. Here, the artist blocks in a solid area of tone with black.*

▽ **5** *Blue, violet, yellow, emerald and light green are glazed lightly on to the fish. Here, the artist glazes pink between patches of violet and blue.*

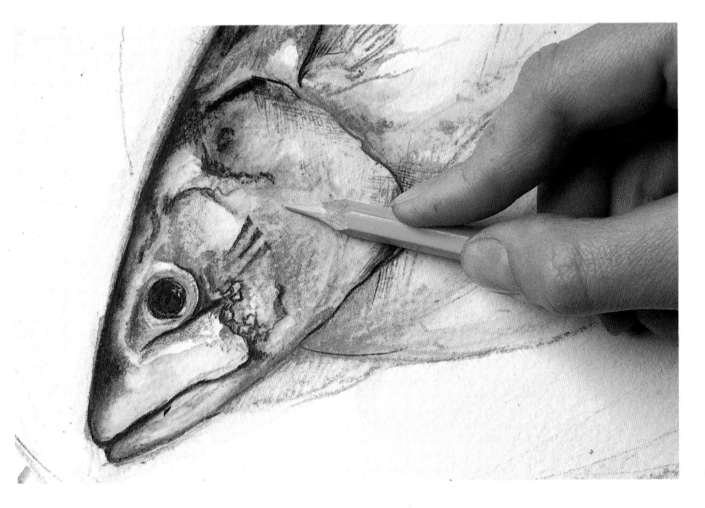

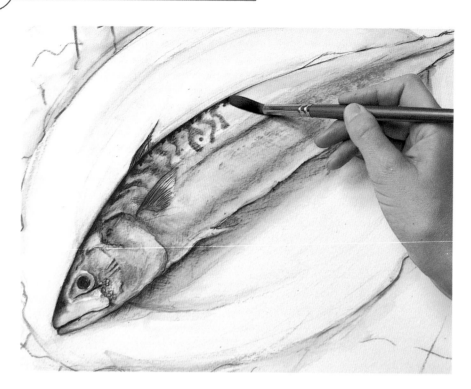

◁ **6** *The glazed colours are dissolved with clean water to produce a rainbow effect on the head of the fish. The black outline along the back darkens when dissolved with water.*

▽ **7** *Colours are further emphasized and a scalpel is used to scratch back into some of the brighter colours, lightening these with patches of white criss-cross lines. Here, bright blue is applied to brighten the shadow under the gill.*

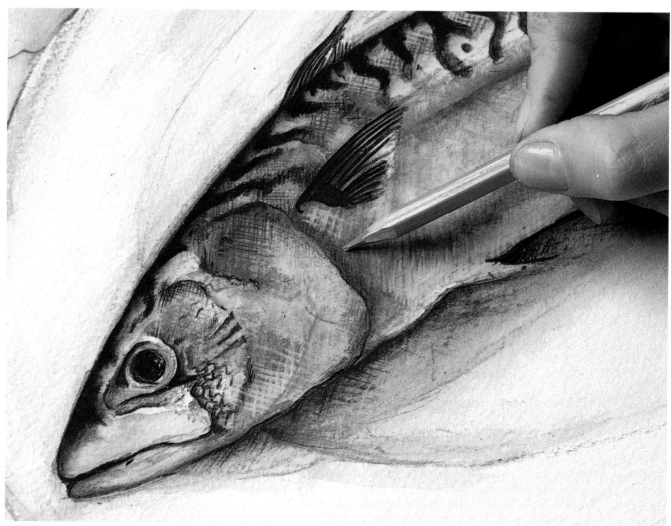

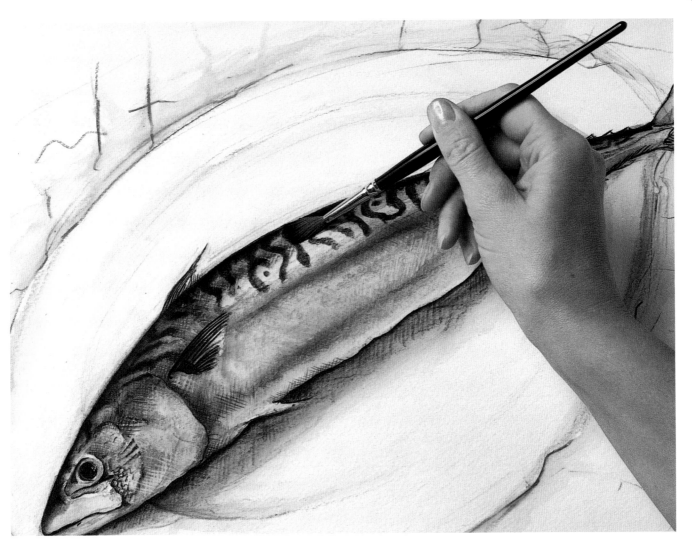

△ 8 Clean water is dragged along the dorsal outline, blending the black markings to form a transparent grey shadow.

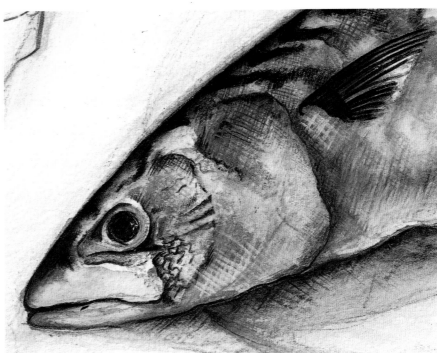

▷ **9** A close-up of the head shows it to be a combination of luminous colour washes, scratched texture and black markings.

65

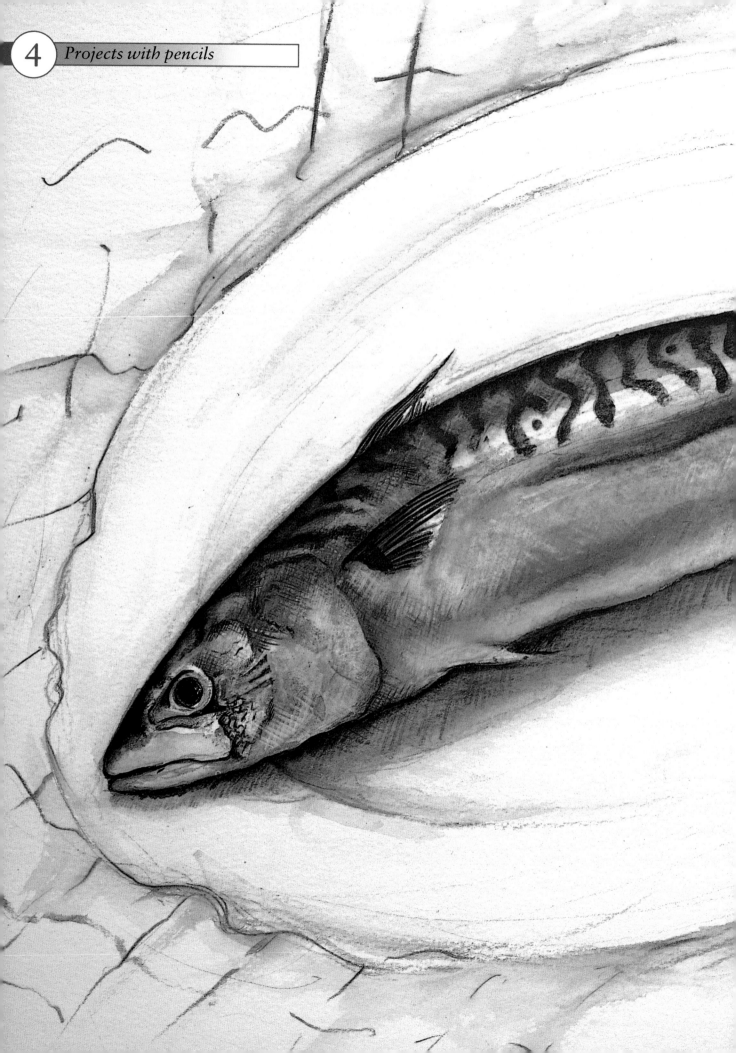

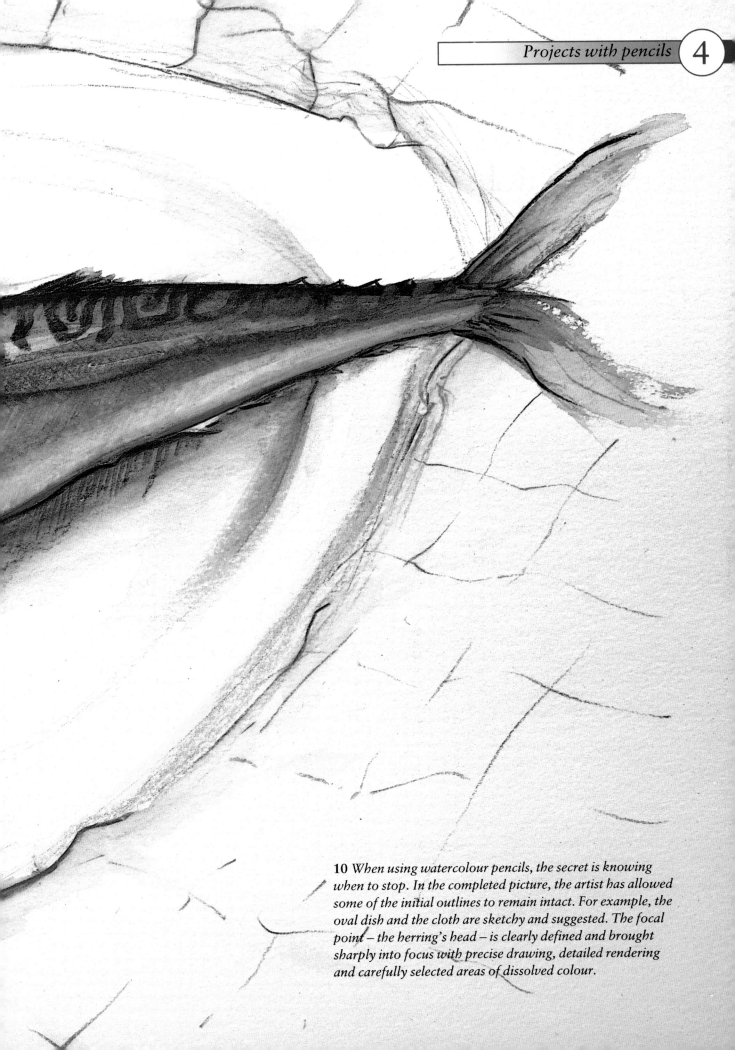

10 *When using watercolour pencils, the secret is knowing when to stop. In the completed picture, the artist has allowed some of the initial outlines to remain intact. For example, the oval dish and the cloth are sketchy and suggested. The focal point – the herring's head – is clearly defined and brought sharply into focus with precise drawing, detailed rendering and carefully selected areas of dissolved colour.*

PROJECTS

RURAL LANDSCAPE

Distance with pencils

You can use a trick to achieve perspective with coloured pencils, as the artist has done in this case. Foreground objects, like the light-green grass here, can be drawn with big, bold, loose strokes. For objects in the distance, you can use smaller, tidier strokes, making them appear to recede; the trees here recede in this way, even though they are in similar colours to the foreground grass.

This is a simple way of creating distance and space when you don't have the opportunity for linear perspective and the distant colours are not obviously paler or bluer. You might encounter this situation on a clear day, when the trees on the other side of a field seem as bright as those close up. The trick is obvious when explained; it really works and yet many people never make use of it.

As a result of this technique the trees in the distance in this picture stand out quite clearly; they do not fade into a haze. Their clarity forms part of the attraction of the picture.

Watercolour pencils were used, but in this case the process was not a long one. The pencils can be a good quick sketching medium. The landscape here was done in chunky strokes and water was added to produce areas of contrasting solid tone.

The composition called for little light and shade; it was made up mainly in blocks of local colour applied in a loose, textural way. The colour range was limited to greens and autumnal foliage colours.

A rich variety of textures is one of the main features of this landscape, and the artist makes the most of this by treating each texture in a different way. Trees are drawn as solid blocks of tone; the fields are flecked with short strokes to give the impression of grass. Sketchy foreground objects contrast effectively with the tighter, more controlled strokes used on distant trees and bushes.

△ **1** *For this landscape sketch, the artist starts by defining the picture area with strips of masking tape. The subject is then established in loose blocks of scribbled colour and water applied to selected areas.*

▽ **2** *The background is yellow ochre; the trees dark green and black. Three tones of green are used for the grass.*

▽ **3** At this stage, the background and sky appear as light washes of pale colour. In the foreground, bushes, trees and grass are left as heavy, scribbled strokes.

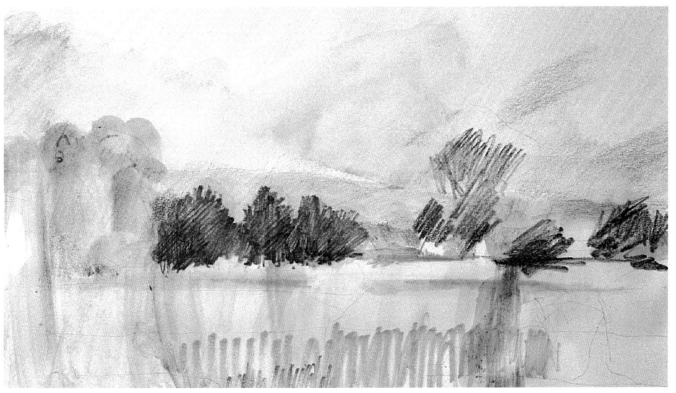

▷ **4** *Warmer browns and yellows are added to the foreground. Again, strokes are broad and scribbled, contrasting with the washy background areas.*

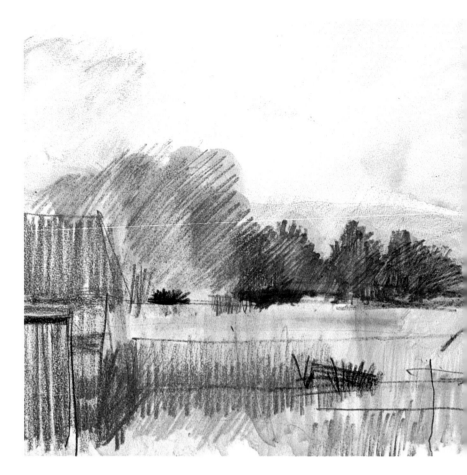

▽ *5 Colour and tone are added to the fields in the foreground. Here, the artist uses dark brown to block in a ploughed field.*

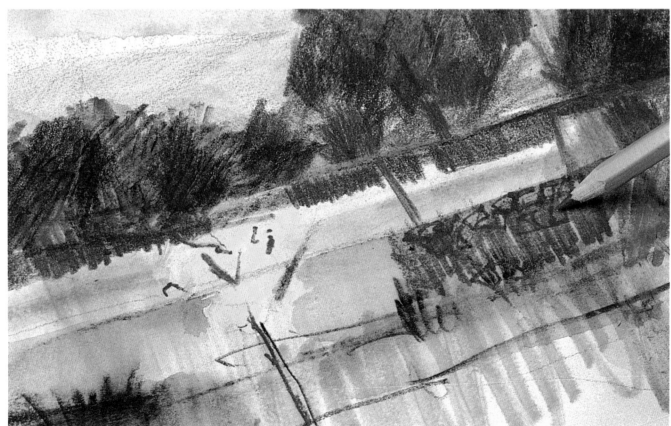

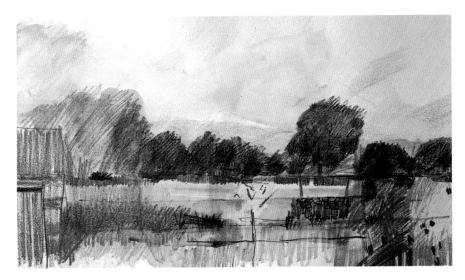

△ **6** *Now the foreground, middle distance and far distance are emerging as three distinct areas. Already, the artist has established a sense of distance and space in the drawing.*

▽ **7** *More loose texture is applied to the foreground. Here, bold flecks of warm brown are introduced to break up a yellow bush.*

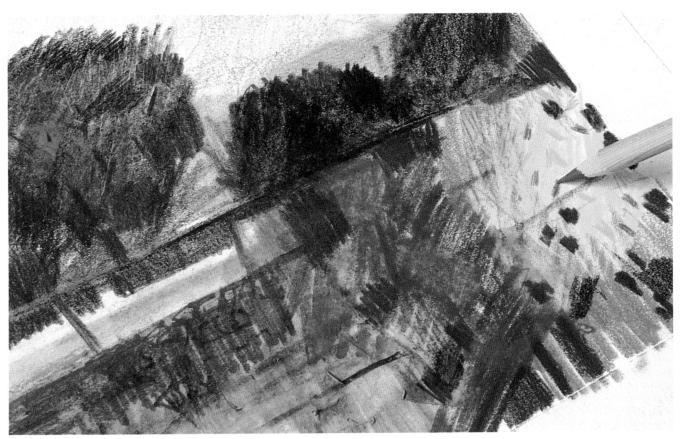

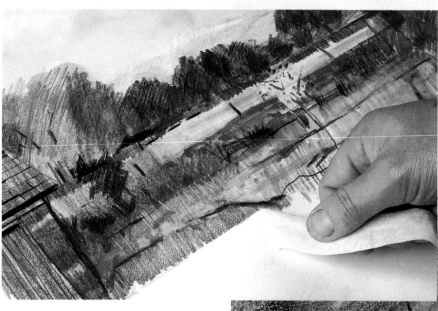

△ **8** *The masking tape is removed to reveal a clean edge.*

▷ **9** *The landscape is now complete. Without including any detail, the artist has used the size and texture of the pencil strokes to create perspective in this small colour sketch. By dissolving and disguising the pencil strokes in the sky and hills, a sense of distance has been suggested. The background trees – those furthest away from the artist – are drawn in similar dark greens with dense pencil strokes; foreground trees and bushes are loosely sketched, each bush containing a range of contrasting tones and colours.*

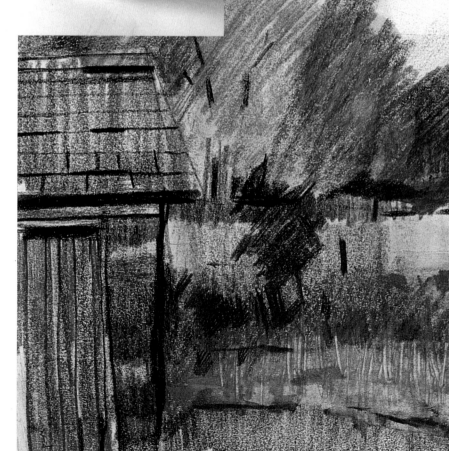

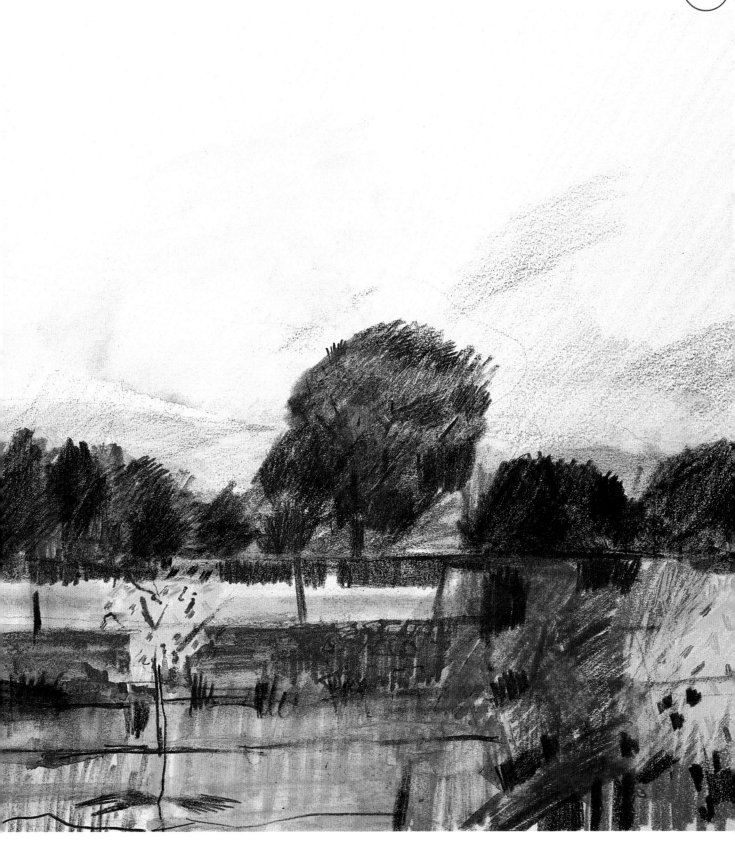

TECHNIQUES

SKETCHING

The area where coloured pencils really come into their own is sketching. Here the medium has all the advantages. Coloured pencils can be slipped easily into the pocket and brought straight into action when you arrive at a sketching-spot. They can produce line just as easily like a graphite drawing pencil or as part of a colour scheme, and they can also be used to indicate areas of solid colour.

If you are making a preliminary sketch with a view to embarking upon a painting at a later date, the colours are recorded for you there and then as you make the sketch. Tone is more difficult to record, but many artists make a separate tonal or monochrome sketch of the subject, using either a graphite pencil or a black or dark-toned coloured pencil.

Colour notes
Coloured pencil sketches are often used by outdoor painters when there is insufficient time to finish a painting. If this happens, you can make a rapid, coloured pencil sketch of your subject, and take this home to work from in the studio. You will be surprised how much information can be contained in a small, accurate colour sketch.

It is a good idea to carry a small pocket-size sketchbook with you at all times. Take every opportunity to make quick on-the-spot drawings of anything that catches your attention during the day. Your sketchbook will prove an invaluable source of reference and inspiration, and can be relied on for ideas and subject matter at a later date.

Another advantage of the sketchbook – sketching calls for close observation. If you have to observe something closely enough to draw it, the image is often then committed to memory and enables you to paint from memory afterwards.

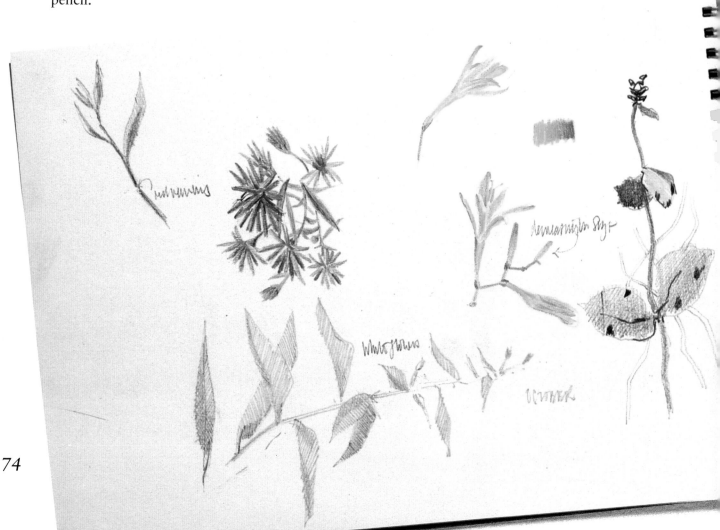

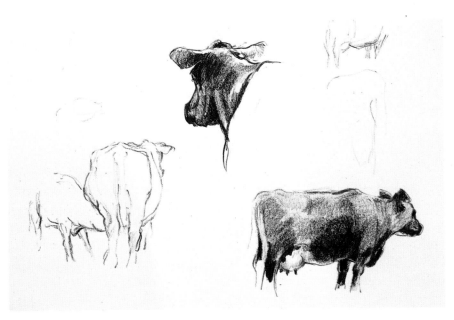

◁ *A rapid on-the-spot sketch of calves and cows. The drawings were used by the artist in a subsequent painting.*

▽ *Typically, a sketchbook is a visual diary – a useful source of reference for the artist. These sketches record some of the flowers spotted during a trip to the countryside.*

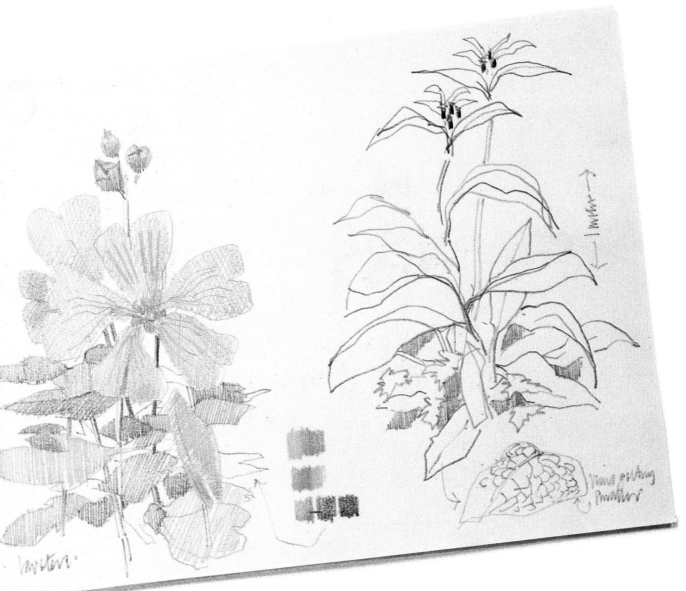

TRANSFERRING A SKETCH

Imagine you have made a sketch which is lively and interesting and now you want to turn it into a more finished drawing, but you do not want to lose the way you put the lines on to the paper originally. For this – or any other – reason, you might want to transfer the sketch on to a different sheet of paper.

This can happen if the sketch is too heavy or has too many corrections and overdrawn lines to enable you to develop it further. In many cases the paper on which a quick but successful sketch was made is too flimsy for a finished drawing. There are various ways of transferring an outline of the sketched image on to a fresh sheet of paper, ready to make your coloured pencil drawing.

The light box
If you have a light box, the job will be easy. Lay your rough sketch on the box and the drawing paper on top of this. Most light boxes are powerful enough to enable the drawn image to show through, even when using cartridge paper. You can then trace the outling drawing, ready to develop. Keep the tracing accurate but loose – remember, you want to retain the liveliness and freshness of the initial sketch.

Tracing a sketch

◁ *The artist starts by making a loose sketch of the subject.*

▷ *Pastel pencil is then scribbled heavily on to the reverse side of the sketch. This can be done in more than one colour; for this demonstration, the artist used blue and green.*

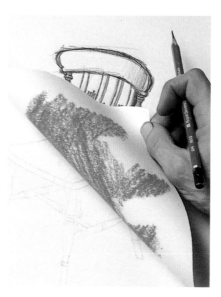

◁◁ *The outline of the subject is traced firmly with a well-sharpened, hard drawing pencil.*

◁ *The sketch is lifted to reveal an accurate, fine line drawing.*

Making a grid

There will be occasions when you have made a sketch or small drawing and would like to develop this on a larger scale. The best way of transferring an image on to a bigger sheet of paper is this: start by drawing a grid of equal-sized squares or rectangles on to the sketch. Draw a similar grid, consisting of the same number of squares or rectangles, on the large paper. These must be the same proportion as those on the small grid. Copy the picture, section by section, from the small grid to the large grid.

Graphite tracing

No light box? All is not lost. What you do here is to scribble lightly across the back of the sketch with soft graphite pencil or graphite stick (you could coat it with graphite powder if you have any). Then place the sketch over the drawing paper and trace the sketch carefully with a sharp drawing pencil. The outline should be clear enough to act as a guide for your finished drawing.

Enlarging a sketch

◁ *The sketch is measured and divided into regular squares or rectangles. The same number of squares or rectangles, of the same proportion as those which divide the sketch, are drawn on to the larger support.*

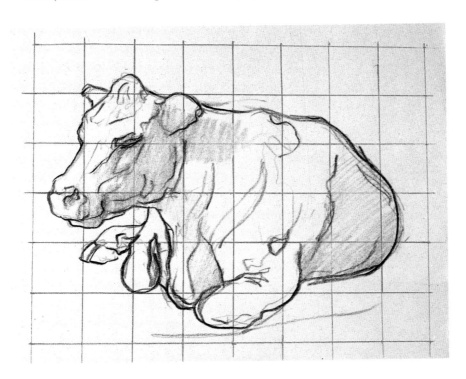

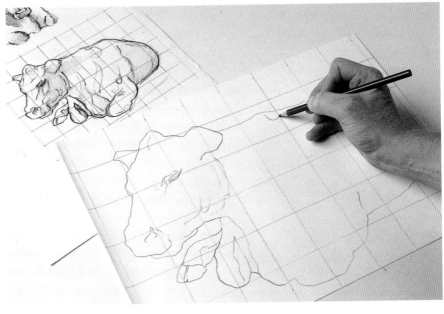

▷ *The image visible in each small square or rectangle is copied to occupy the same space in a square or rectangle on the larger support.*

PROJECTS

DRIED FLOWERS

Mixed media

This still-life captures the colour and form of a vase of poppies and dried grasses by making use of the fact that coloured pencils work well with many other media. Coloured pencils can be mixed happily with such media as pastels, watercolour paints, charcoal and pen and ink. Unless you are aiming at random blending effects, remember that watercolours and ink need to be left to dry before proceeding.

Dried flowers and grasses make excellent subjects for a drawing or painting because they remain constant – unlike many freshly cut flowers, which start to droop and change shape as soon as they are placed in a warm position. Blooms usually open up in the sunshine and begin to close in the late afternoon and evening, which is frustrating if you are still struggling to establish the shapes.

This picture was done with a combination of coloured pencils, watercolour paints, ordinary pencil, charcoal and soft pastel. It was a fairly quick, spontaneous project.

In the choice of materials, the aim was to achieve an attractive combination of contrasting textures – the soft, feathery strokes of pastel and the heavier lines of charcoal, for instance. In some areas, watercolour and coloured pencils were blended to get washy effects, both in the background and in parts of the foliage.

In this picture the background details were ignored and the area behind the vase was left to recede into washy suggestions of a corner. Coloured pencils are not really suitable for the large areas of dark tone that appear here in the real background, so feel free to isolate a subject from some of its surroundings.

From a sparse outline that nevertheless covered the whole composition, the artist moved on to detail with coloured pencils, rendering some of the brighter flowers with pastel. Charcoal was used in the late stages for darker markings.

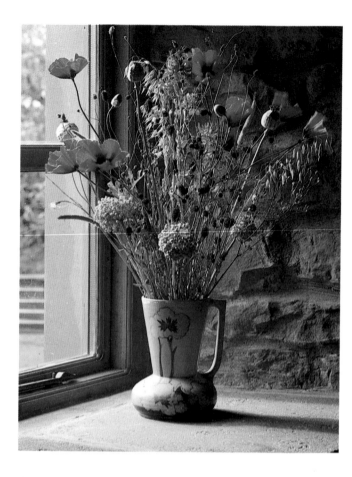

△ **1** *For this mixed-media project, the artist chose a vase of dried grasses and striking red poppies. The subject combined line, colour and texture, and she started work with a range of materials to hand – including watercolour pencils, soft pastels and charcoal.*

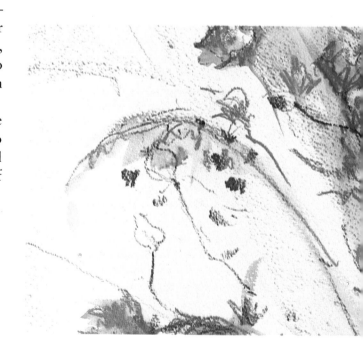

△ **2** *Working of a sheet of rough watercolour paper, the vase and table are sketched in with watercolour pencil and pastel; the pencil colours are then dissolved with a brush and clean water. The positions of the flowers and grasses are indicated lightly with charcoal.*

▽ **3** *Bright red watercolour pencil on the poppy heads is dissolved with water. The grasses are sketched in brown, green and ochre, using watercolour pencils and soft pastel.*

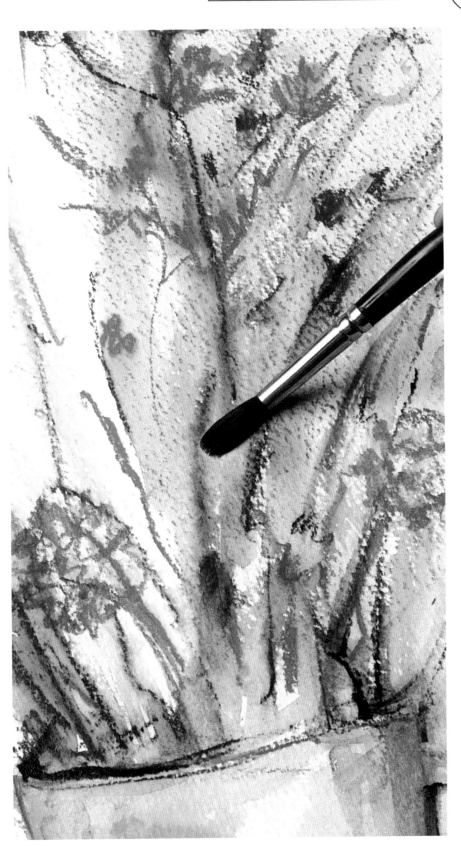

△ **4** *The stalks are dissolved and softened with a large sable brush and plenty of water.*

▽ 5 *A combination of sensitive drawing and bold colour conveys the varied textures of the subject. The delicate, spindle-like lines are obtained by holding pastels and pencils loosely, keeping the hand well away from the drawing tip.*

▷ 6 *A stick of fine willow charcoal is used for the dark detail on the poppies and the finer grasses.*

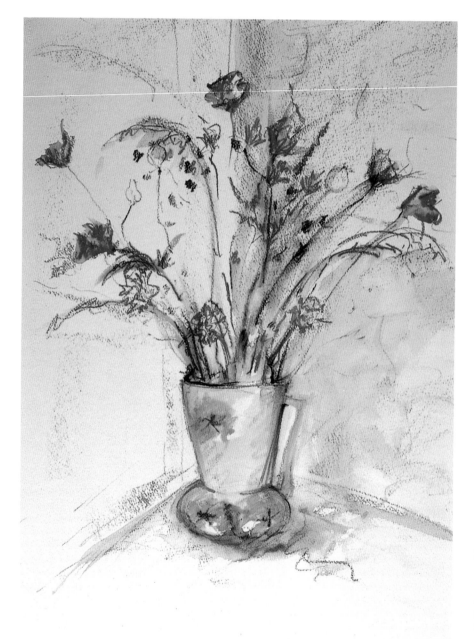

▷ 7 *A detail of the flowers and grasses reveals a mass of lines, textures and colours – including three different greens, brown, ochre, red, pink, violet and black.*

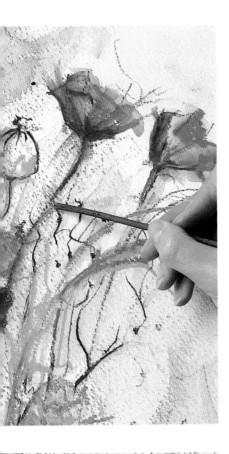

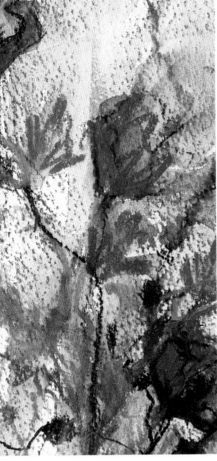

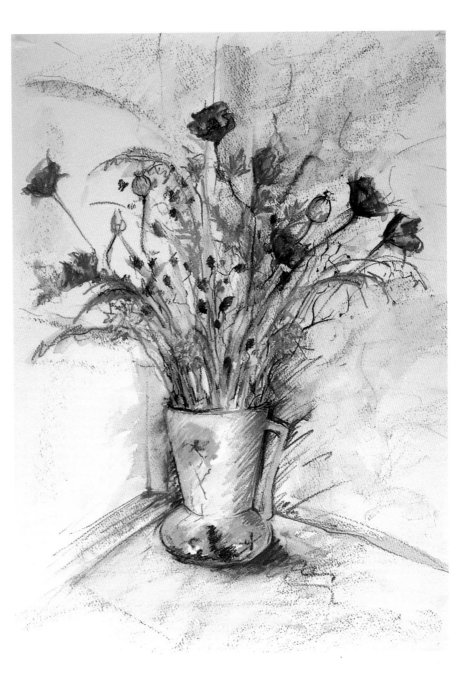

△ 8 *While drawing and painting the flowers and grasses, the artist took advantage of the strong light source. However, in the completed painting, the background is deliberately simplified; the window and sill are suggested with just a few strokes of dark colour.*

KITCHEN STILL-LIFE

Toned paper

A cold, bluish-grey paper has been chosen for this picture of bread and vegetables in which the subject is picked out in isolation, ignoring the background detail of the table and kitchen. The paper itself becomes the main background, with the composition set in the centre and no part going up to the edges.

Pastel pencils

Pastel pencils, which were employed for this picture, are often used on toned or tinted paper like the surface illustrated here. These pencils lie somewhere between coloured pencils and pastels. They are chunky and they are crumbly rather than waxy, making them quicker to use if you want to fill in large areas of tone or colour.

Although he was painting a colourful picture, the artist chose a subdued and essentially cool coloured paper to offset the predominantly warm colours of the subject. Toned paper also gives you an already established middle tone, so you don't have to get rid of lots of white before beginning to relate the tones to the picture. The artist was therefore able to start straight away with establishing some of the lighter tones of the cloth and bread, as well as the darker shadow tones.

Light over dark

Because they are crumbly, pastel pencils allow you to break the general rules of coloured pencils and work light over dark. The highlights can be added at a later stage, because the pigment adheres to the paper surface, allowing white or light colours to go over darker ones to some extent. Here, for instance, the artist adds highlights to the crusty bread and reflections on the shiny aubergine.

The artist worked in light, overlaid strokes, using finger-smudging in some areas to blend the colours.

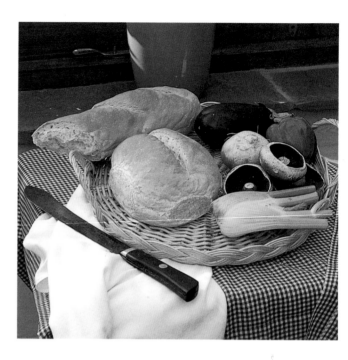

△ **1** *A rich variety of textures and a wide tonal range attracted the artist to this subject. The drawing is done in pastel pencils on grey Fabriano paper.*

▽ **2** *A very light outline is drawn in black, and the artist starts immediately by blocking in a few of the local colours and general tones. Colours are applied densely in close strokes.*

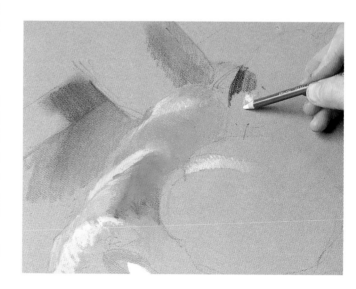

▷ 3 *The bread is drawn in warm orange, red and brown with white highlights; the tones of the background and table are black, brown and violet.*

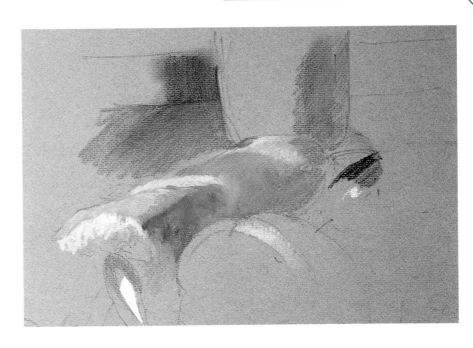

▽ 4 *Some of the darkest tones, the aubergine and the shadows on the bread, are blocked in with black, blue and violet. The reflected highlight on the aubergine is white, blended with the finger.*

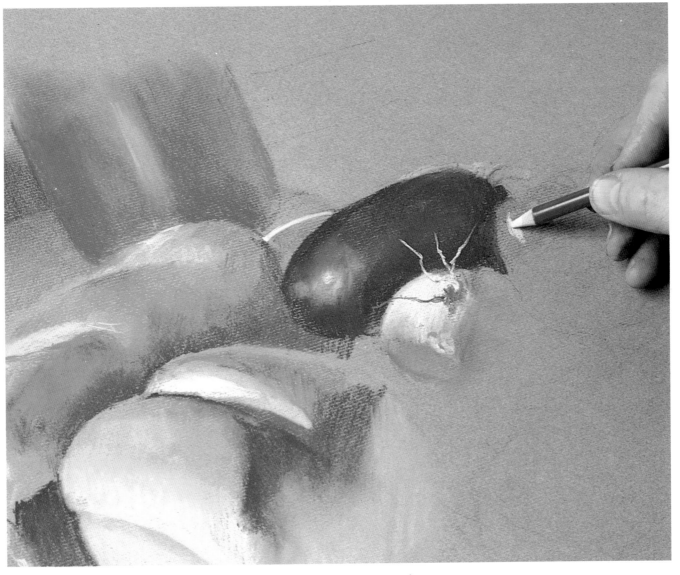

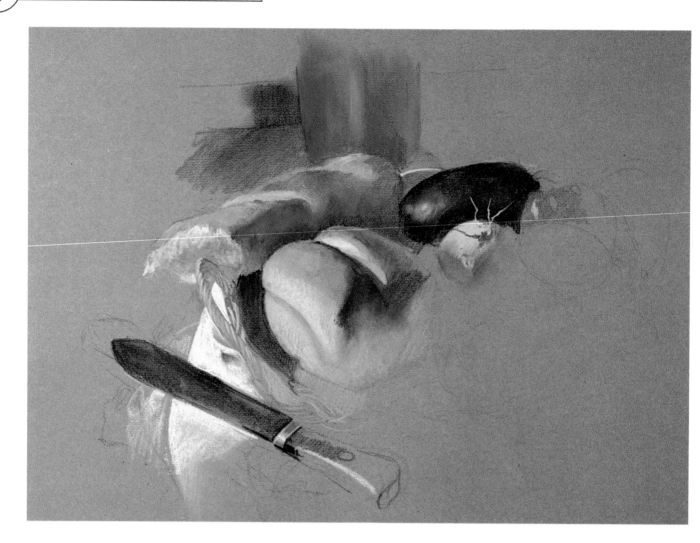

△ 5 *At this stage, the main colours and tones have been established in one half of the drawing. When working with pastel pencils, the artist always starts at the top left and works downwards. This minimalizes accidental smudging with the drawing hand.*

▷ 6 *The plate is dense white, the pencil strokes heavy and even.*

▷ 7 *The rest of the vegetables are now added. Directional pencil strokes are used to emphasize and describe the textures of the chicory leaves and mushrooms.*

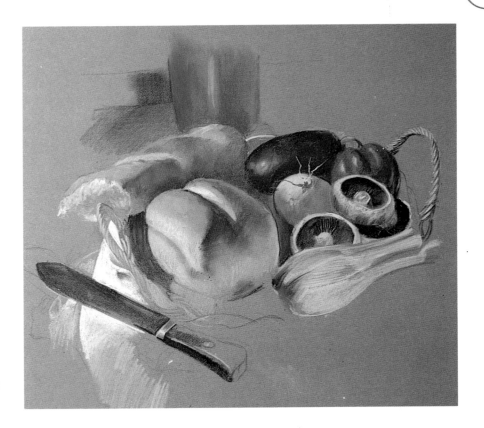

▽ 8 *The mushrooms are white, black and brown with touches of warm orange; the chicory is predominantly green, white and yellow with added greys and browns for the shadows.*

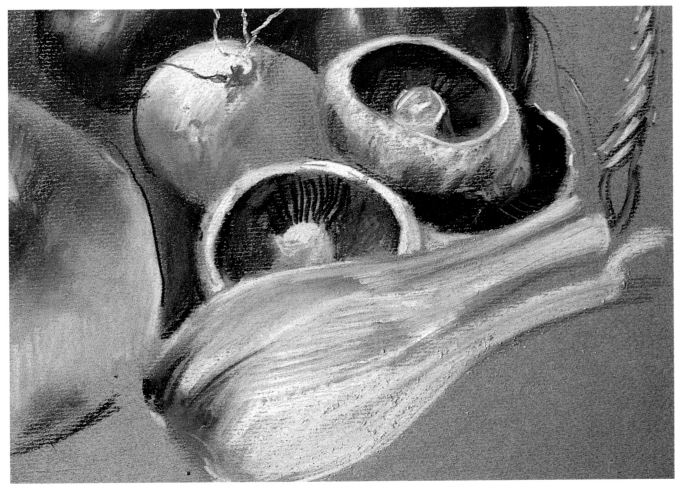

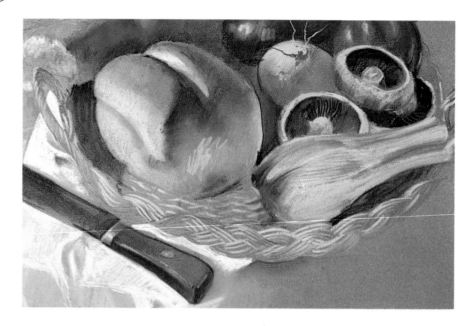

△ **9** *The woven basket is drawn in three tones – white, yellow and yellow ochre. The artist has followed the woven pattern, using white on the light upper areas, and yellow and yellow ochre on the shaded area.*

▽ **10** *The contrasting tones range from bright white to the dark browns and black of the deep shadows.*

▷ **11** *Finally, the vase is drawn in bright blue and white. Flecks of the cool blue paper, used as a medium tone to help the artist establish the early lights and darks of the subject, show through between the pencil strokes. These flecks help to unify the picture by linking the subject to the surrounding empty space.*

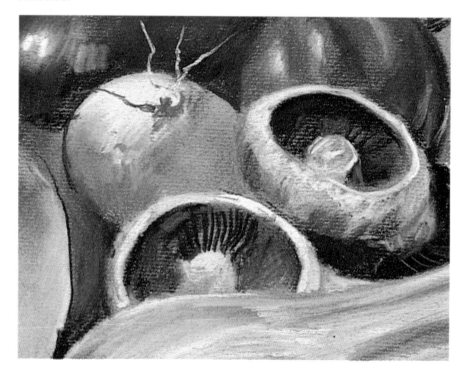

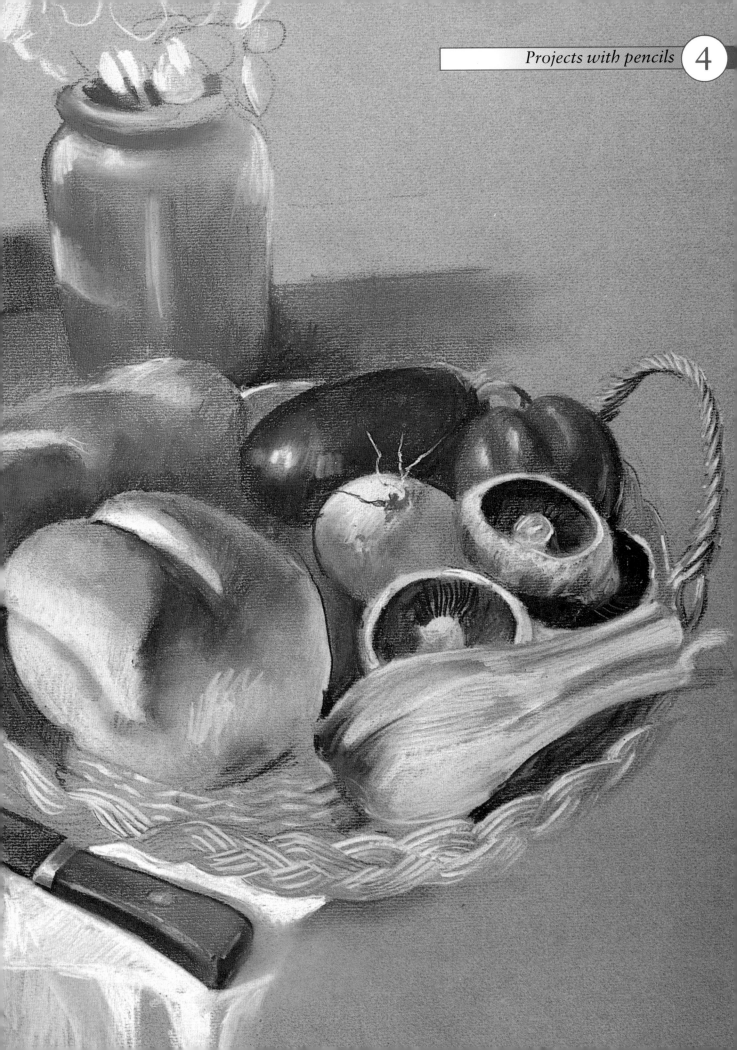

PROJECTS

WILD FLOWERS

Pencil and paint

The artist used watercolour paints to establish the basic tone and shape of these wild flowers and herbs in their wrapping paper hovering against a neutral background.

In effect, the picture started as a painting and ended up as a drawing.

Coloured pencils can often be used on top of watercolour paint to make a quick tonal sketch of the subject before developing it in pencil. The result gives an attractive contrast between the sharp linear or hatched pencil marks and the translucent wash of the watercolour paint.

Uses of watercolour

Many artists use watercolour paint to put in a washed backgroud. This can be either a graded wash from one side of the picture or from top to bottom, to give a varied start; or you might like to block in the main background in two or three colours. Usually, the washed background is allowed to dry before pencils are applied.

The artist in this case has used watercolour paint in a different way – as a foundation on the actual subject itself. She has blocked in the flowers with watercolour, using mainly local colour. Then she works back into this with pencils, adding texture and form and strengthening the tones and colours.

Focal point

She works into the flower heads in carefully observed detail, defining the petals and identifying the main flowers. She has deliberately left other flowers only sketchily drawn with the pencils, so that the focal point is actually in the centre of the bunch. In the late stages, she used a hard drawing pencil to establish dark tones.

Because she used quite a lot of water, the artist stretched the paper first to prevent the saturated support from buckling.

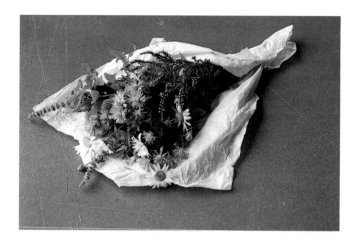

△ **1** *A bunch of herbs and flowers, randomly wrapped in tissue paper, is the subject chosen for this mixed-media painting, which combines watercolour washes with linear coloured pencil drawing.*

▽ **2** *The artist starts by painting the flowers and leaves in loose washes of diluted watercolour.*

▷ **3** *The violets, greens and yellows are diluted with plenty of water and allowed to dry. It is important to keep these initial colours pale so that subsequent coloured pencil drawing will show up clearly.*

▷ **4** *One of the central daisies is drawn in detail using a well-sharpened black pencil. The artist intends to draw the central flowers clearly and to leave peripheral leaves and flowers as loose washes of watercolour.*

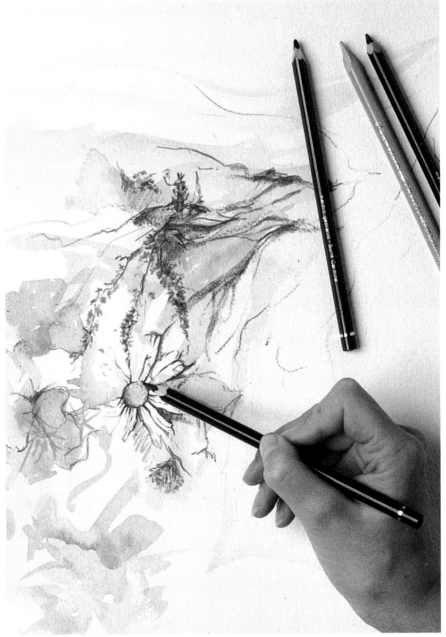

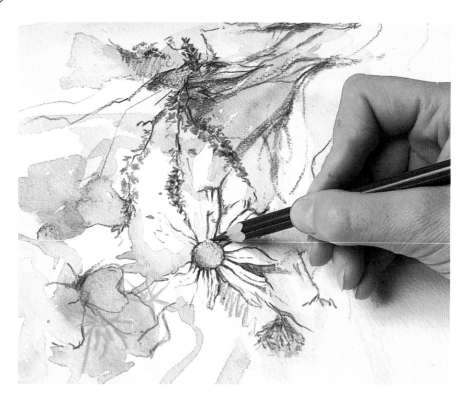

◁ **5** *The yellow flower centre is shaded with tiny dots of black pencil.*

▽ **6** *Heather and Michaelmas daisies are defined in coloured pencil. Here, the artist works into the Michaelmas daisies in deep violet.*

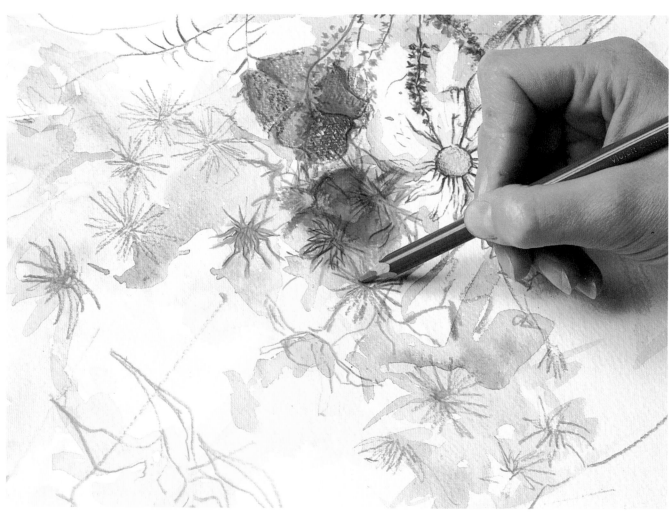

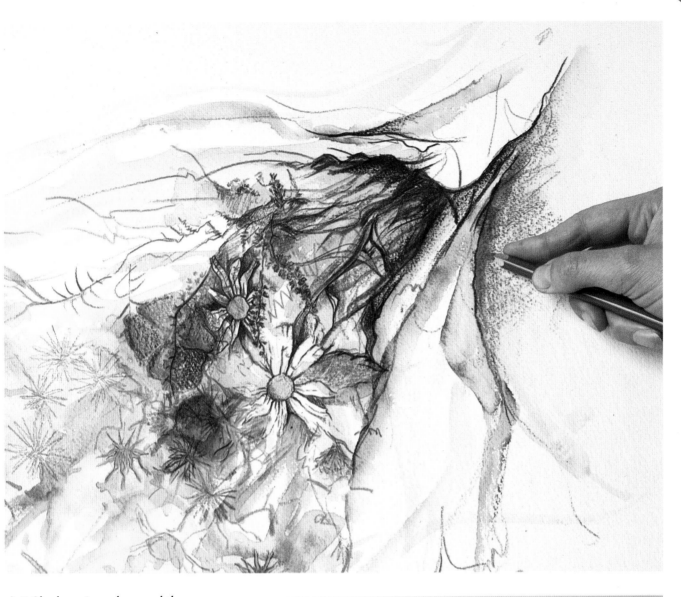

△ 7 Shadows in and around the
paper wrapping are darkened with
washes of watercolour and
developed in glazes of coloured
pencil. Here, the artist starts to glaze
the table, using the side of the point
of a light brown pencil.

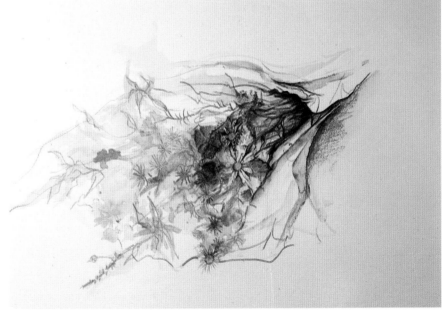

▷ 8 Using the watercolour shapes
as a starting point, the artist has
drawn the main flowers and leaves
in accurate detail. Where necessary,
broad tones have been strengthened
with darker washes of watercolour
paint.

91

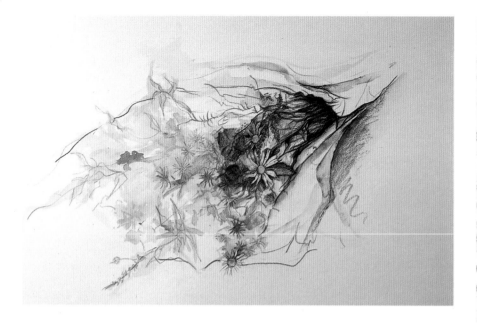

△ ◁ **9** *The artist starts to expand the shading of the wooden table, using loosely scribbled strokes of light brown pencil.*

◁ **10** *The table top is further developed, establishing this as the solid surface on which the bunch of flowers is lying.*

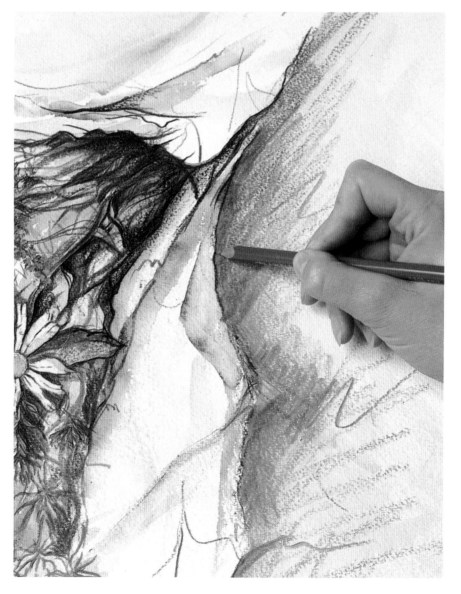

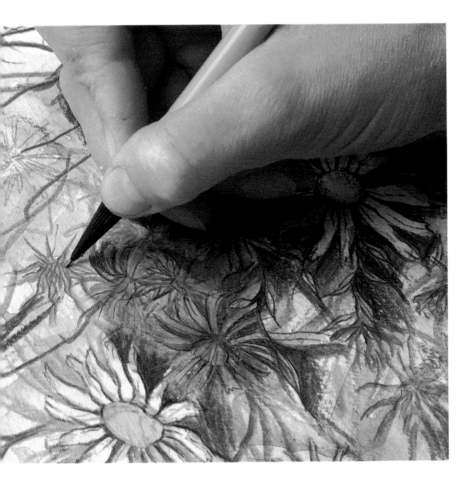

◁ **11** *For the petals of the smaller Michaelmas daisies, the artist uses the fine point of a technical drawing pencil.*

▽ **12** *The central flowers stand out in botanical detail, forming the focal point of the painting. Other flowers and foliage remain as loose shapes of watercolour wash.*

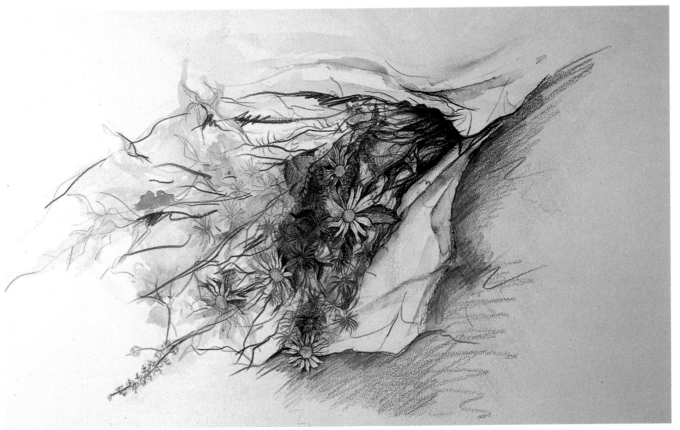

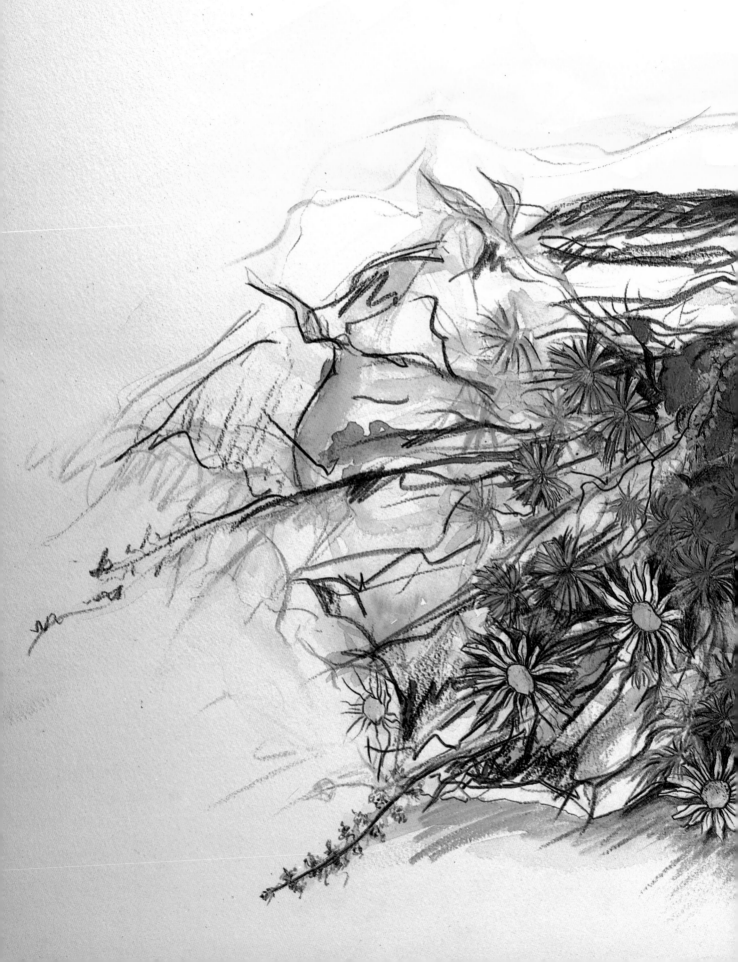

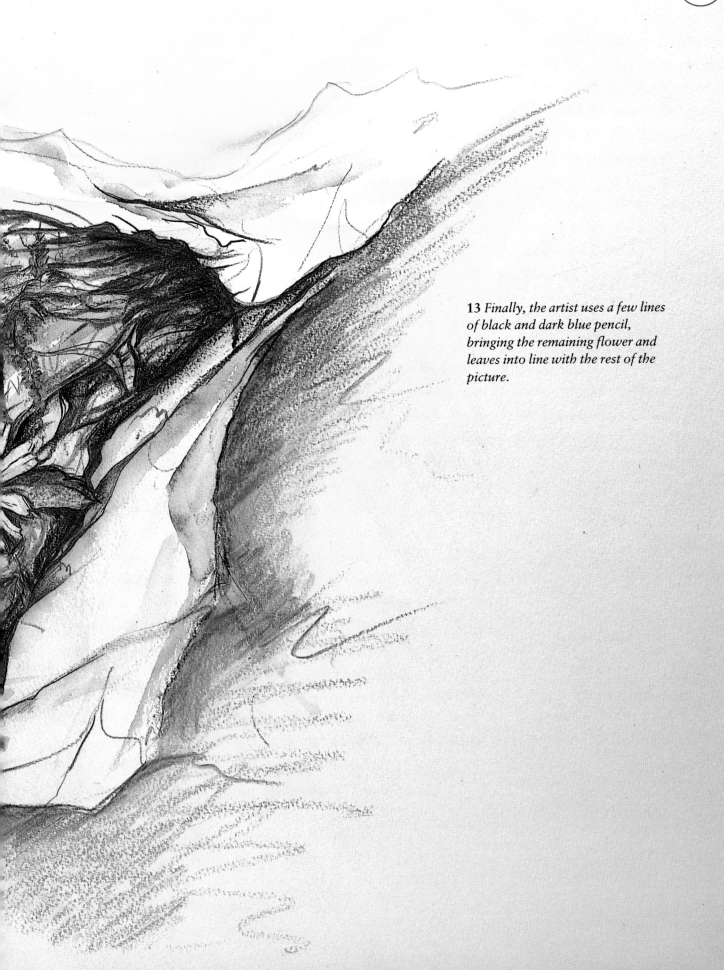

13 *Finally, the artist uses a few lines of black and dark blue pencil, bringing the remaining flower and leaves into line with the rest of the picture.*

INDEX

A
Animals, drawing of
42–3

B
Blending 32, 42
Burnishing 32–3, 42–3

C
Canson Mi Teintes,
paper 28
Caran d'Ache, water-
soluble crayons 22
Charcoal 79–80
Chinagraph 23
Colours, mixing 12, 14,
16–19, 33
Colour, opposites 15
Colour temperature 15
Coloured pencils, the
brands 23
choosing 22–3
manufacturing of
24–5
Composition 68
Conté, drawing sticks 6
Cross-hatching 16,
18–19, 30, 32–4, 36

D
Drawing board 20
Drawing, miniature 11
Dufort, Antony 5
Dürer 6

E
Erasers 20–1, 33

F
Faber-Castell, pencils 23

Fixative 9
Focal point 88
Frottage 50–1

G
Glazing 16, 18–19, 30,
32–4, 44–7, 63, 91
Graphite pencils 5
Grid, making a 77

H
Highlights, making 17,
35–6, 39–40, 44, 83
Holders, for pencils 20
Howes, Pippa 8, 31

K
Karismacolor, pencils 23
Kohinoor projecto-
color, pencils 23

L
Landscape 54–9, 68–73
approaches to 52–3
Leonardo da Vinci 6
Light box 76
Line, impressed 50

M
Masking tape 68, 72
Mixed media 9, 78–81

O
Optical mixing 4, 16,
Out of doors, working
10, 51, 54, 74–5
Overlaying, colour 17,
34, 37, 51, 54, 56, 82

P
Paper, blocks of 11, 27
by the roll 11
cartridge 11, 26–7
coloured 28
hand-made 27
hot-pressed 26
not, 26
pastel 26, 28
rough 26, 54, 79
smooth 26, 44
tone 28, 82
watercolour 11, 26–7,
62–7, 79
Pastel, soft 9, 79
Pastel, pencils 82
Pattern 52
Perspective, technique
68, 72
Projects
Autumn apples 44–9
Bowl of onions 36–41
Dried flowers 78–81
Herring 62–7
Kitchen still-life 82–7
Rural landscape
68–73
Suzie the cat 42–3
The sheep bridge 54–9
Wild flowers 88–95

R
Rexel, pencils 22–3
21–3
use of 60–9, 72, 79,
88–9

S
Sandpaper, pads of 20–1
Schwan, pencils 23

Scribbling 16, 18–9,
34–5
Sets, coloured pencils 23
Seurat 16
Sgraffito 50–1, 66
Shading 34
Signac 16
Silverpoint 6
Sketchbook, the 74–5
Sketches 6–7, 74–5
enlarging 77
from photographs 42
transferring 76–7
Smith, Adrian 7
Sopwith, Camilla 7
Special effects 50–1
Stabilotone, metallic
pencils 22
Still-life 36–41, 44–9,
62–7, 78–95
mixed media, 78–81

T
Taylor, William 9
Texture, creating 52–3,
68, 71, 80, 85
Tone 86
Torchon 20, 33
Tracing, with graphite
77

W
Watercolour paint, use
of 11, 88–9
Water-soluble pencils
18–19, 33, 35